PESELLINO
A Renaissance Master Revealed

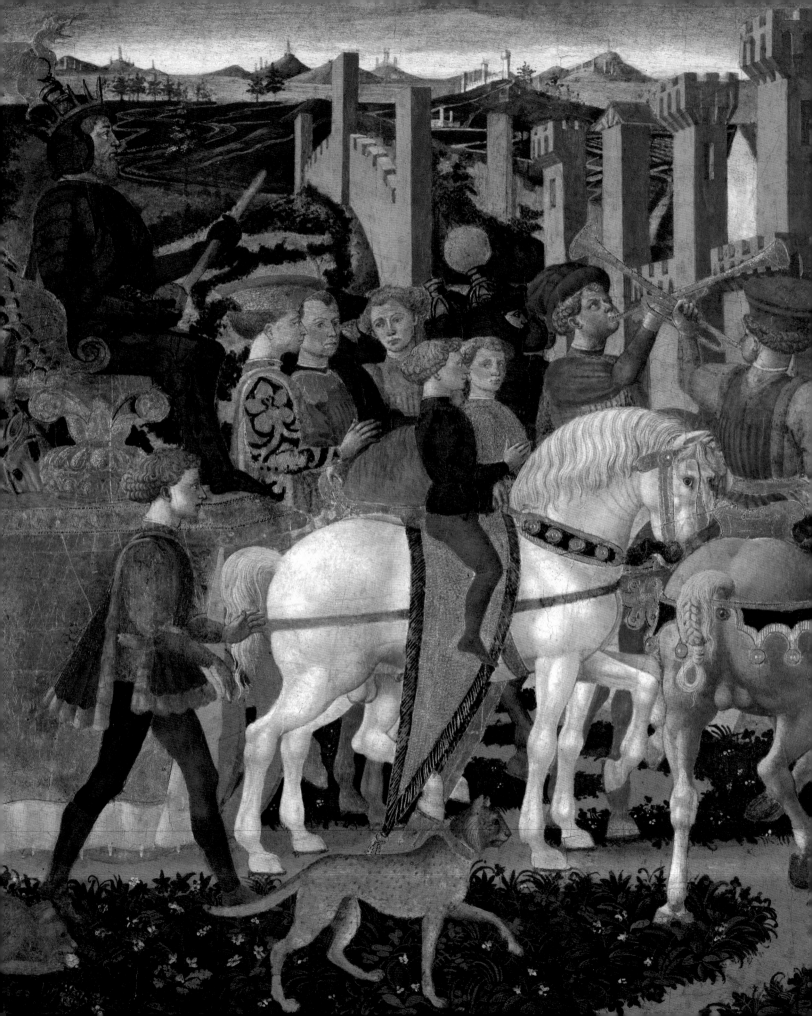

PESELLINO
A Renaissance Master Revealed

LAURA LLEWELLYN
WITH CONTRIBUTIONS BY JILL DUNKERTON
AND NATHANIEL SILVER

National Gallery Global, London
Distributed by Yale University Press

CONTENTS

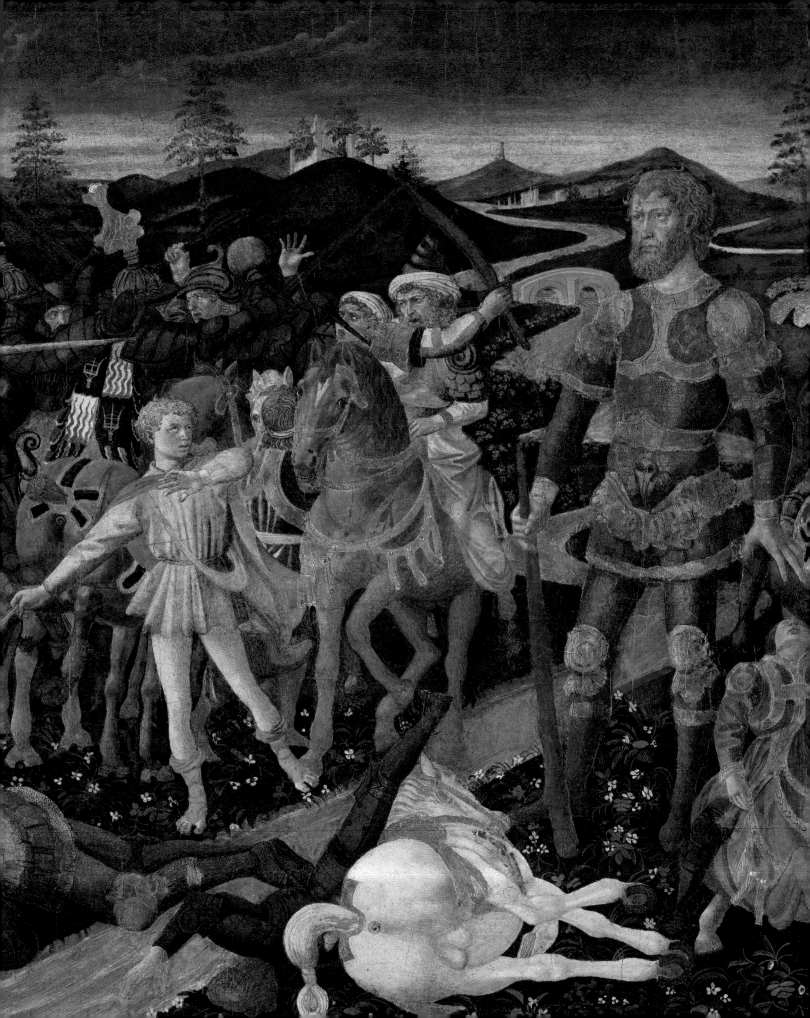

DIRECTOR'S FOREWORD

THIS is the first exhibition ever devoted to the Florentine painter Pesellino (1422–1457). He was born Francesco di Stefano, just as Cosimo de' Medici was consolidating his authority over the Florentine Republic, and he died aged 35, an admired and successful artist with a thriving workshop, enjoying the patronage of the Medici family and members of the papal court in Rome. He belonged to the same generation as Andrea del Castagno, Domenico Veneziano and Benozzo Gozzoli, but is rather less well known today.

The National Gallery has an important altarpiece he left unfinished at his death, *The Trinity with Saints*, which was completed by Fra Filippo Lippi and one or more members of his workshop. This large panel was subsequently sawn into several parts in the late 1700s, and these various fragments (including one on long-term loan from the Royal Collection) were brought together in the Gallery over the course of a century.

In the year 2000 we were fortunate to be able to acquire from the Loyd Collection two impressive panels of *The Story of David and Goliath* and *The Triumph of David*. Painted in his early thirties, they show Pesellino as a highly skilled storyteller, a painter who understood the new art of perspective, who took on the challenge of elaborately foreshortened forms and who had a masterly competence in animal painting and landscape. The recent conservation of these works has shown how carefully he constructed the scenes and the superb refinement of their execution. It is highly likely that they were commissioned as *cassone* decorations by a prominent member of the Medici family, possibly Piero, Cosimo's son and heir.

The exhibition brings together a small group of works that highlight the varied aspects of Pesellino's activity. We are grateful to the lenders in London, Paris, Lyon, Williamstown and Worcester (MA). In particular, I would like to thank the authors of this publication: Laura Llewellyn, who curated the exhibition; Jill Dunkerton, who restored the David panels; and Nathaniel Silver, who has spent many years thinking and writing about Pesellino.

Finally, I would like to express my thanks to those who have helped fund this exhibition. I am grateful to the Trustees of the Capricorn Foundation, who support the H J Hyams programme of dossier exhibitions at the Gallery. Their ongoing commitment allows us to present a varied succession of focused displays, often centred on works from the National Gallery's collection. I would also like to thank The Vaseppi Trust, Mr and Mrs Giuseppe Ciucci, Count and Countess Emilio Voli, Hannah Rothschild and the Rothschild Foundation.

Gabriele Finaldi
Director, The National Gallery

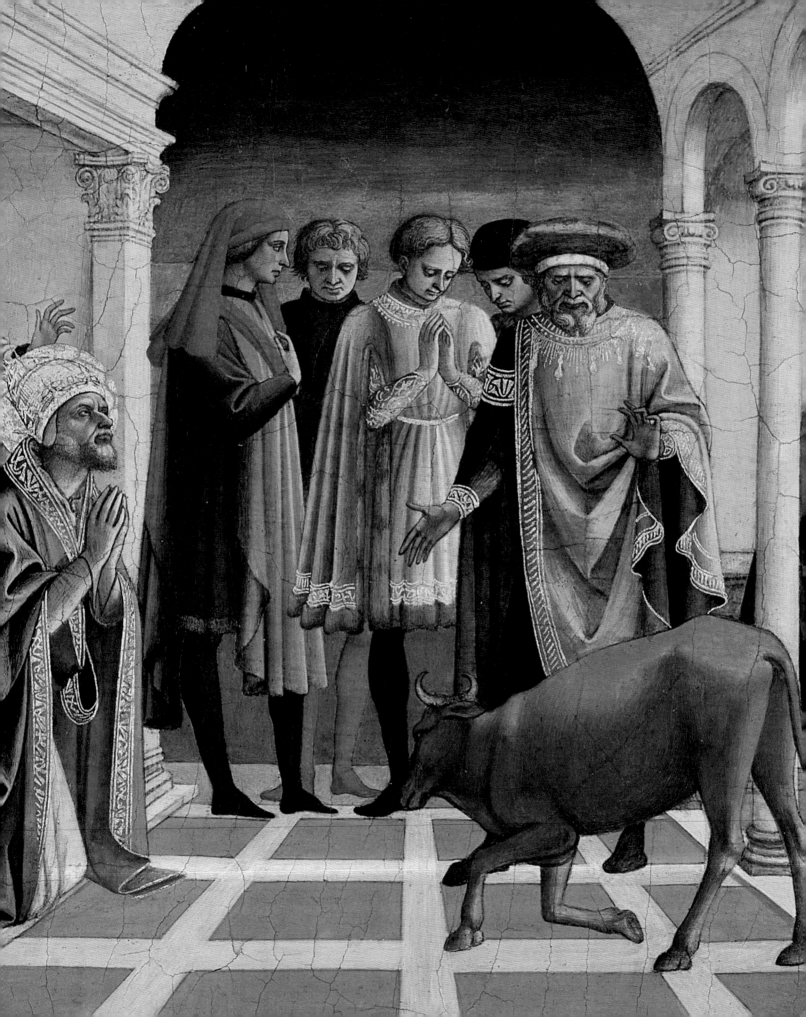

A master painter overlooked

NATHANIEL SILVER

BORN in 1422 in Florence, Francesco di Stefano, called 'Pesellino', rose quickly to fame, painting for some of the most esteemed patrons on the Italian peninsula including several members of the Medici family and Pope Nicholas V. Upon his death, Fra Filippo Lippi may even have memorialised him with a portrait (see cat. 8 and fig. 50). In the sixteenth century, Giorgio Vasari, the Renaissance biographer, consecrated his place in art's history with a brief *life*, leaving tantalising hints of an impressive, if short-lived, career.[1] But who is this mysterious artist and what do we actually know about him?

Francesco di Stefano was born into a family of painters. Both his father and maternal grandfather pursued the profession. By the time Francesco was five, his father had died. He and his widowed mother went to live with her father, Giuliano d'Arrigo di Gioccolo Giochi (died 1446), in the San Frediano neighbourhood. Aged 60, Giuliano was a celebrated painter nicknamed Pesello ('the pea', an off-colour term for the male member).[2] Across the river Arno, on the corso degli Adimari at the heart of the city, Pesello ran a large workshop specialising in banners for festivals, processions and battles. It was profitable enough that he not only owned his workshop and home but also property outside the city in the Chianti region whose rent contributed to his income. Illustrious corporate patrons included guilds, confraternities and the city of Florence. Individuals numbered powerful foreigners like Guido Antonio Manfredi (Lord of Faenza), the Abbot of Camaldoli, local knights, patricians and government office-holders as well as members of Florence's leading families such as the Medici. Pesello was apparently a trusted member of Cosimo de' Medici's household. Documents indicate that the patriarch personally paid for part of the dowry of at least one of Pesello's daughters, the eldest, Pesellino's mother. While common for Medici family employees, the substantial sum suggests that Pesello was no ordinary retainer.[3]

ORIGINS

Training started at a precocious age and by the time he was 11, Francesco was probably already attached to his grandfather's painting workshop.[4] With his father deceased, Francesco was adopted by Pesello as his son.[5] The decision was more than sentimental: it provided tax and other financial benefits (such as free membership in the guild) and, importantly, also meant that he, the father of three girls and no boys, finally had a professional heir.[6] The fact that Francesco eventually took the nickname Pesellino, diminutive of his grandfather's, suggests that whatever the legal arrangements, he embraced the opportunity to capitalise on his grandfather's reputation.

None of Pesello's work survives. However, Francesco's mature drawings point to a remarkable facility for draughtsmanship and design, likely instilled at an early age. Pesello's entire career depended upon his technical and compositional drawing abilities to design for governmental, military and civic commissions, from bunting for state funerals to banners for guild halls and military standards. He apparently excelled at animals, a key emblematic component of coats of arms, and bequeathed this

OPPOSITE
Detail of *A Miracle of Saint Sylvester* (cat. 5)

expertise to Pesellino who turned it towards a different purpose. Beyond drawing, Pesello's strong grasp of design also encompassed the word's conceptual sense, for he was commissioned to resolve particular technical problems with drawings or models, whether on a ceremonial staircase under construction at Santa Maria Novella for the arrival of Pope Martin V or for the cathedral dome, for which Pesello had been appointed as substitute architect for Brunelleschi.[7] Like his grandfather, drawing or *disegno* – both in the literal and conceptual sense – was key to the success of Francesco's career, not only in his ability to reproduce existing patterns and visual formulas but to invent new ones, adapt them to different sizes and transfer them across various media.

Where Pesellino went after Pesello's workshop remains a mystery, but he clearly embraced the latest stylistic developments in Florentine figure design. The teenage painter-in-training likely did several stints in the workshops of the city's leading masters. We do not know for certain, but it is highly plausible that he spent time working for the sculptor Lorenzo Ghiberti, given his grandfather's involvement with the Calimala, the guild responsible for Florence's Baptistry, as well as the documented working relationship between Pesello and the goldsmith.[8] By the time of Pesellino's fifteenth birthday, Ghiberti's team had begun cleaning and chasing of figural elements on the bronze reliefs for the east door of the Baptistry. Despite the sculptural nature of this work, Ghiberti's workshop attracted several young painters including Paolo Uccello and later Benozzo Gozzoli who were clearly influenced by his style, compositional vocabulary and narrative ingenuity. The composition of Pesellino's early coloured drawing in the Louvre (fig. 1) points to a careful study of Ghiberti's panels, while its meticulous technique recalls the precision of bronze chasing (see fig. 12). Chasing Ghiberti's sculpted bronze reliefs was a difficult job that required good

I

S·FRANCSC⊙·S·DAMIANVS· SOSMS·SANTⒹIVS·DEPAI·

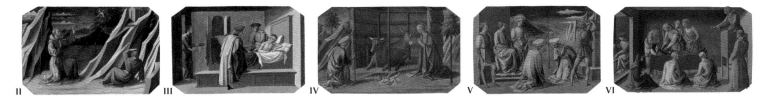

II III IV V VI

Fig. 2 Altarpiece for the Novitiate Chapel,
Santa Croce, Florence, 1440–5
Egg tempera on wood

I Fra Filippo Lippi (about 1406–1469)
Madonna and Child with Saints, 196 × 196 cm
Gallerie degli Uffizi, Florence

II–III Francesco Pesellino (1422–1457)
The Stigmatisation of Saint Francis and
The Miracle of the Black Leg (cat. 1), 32 × 94 cm
Musée du Louvre, Paris

IV–VI *The Nativity*, *The Martyrdom of Saints
Cosmas and Damian* and *The Miracle
of Saint Nicholas*, 32 × 145.5 cm
Gallerie degli Uffizi, Florence

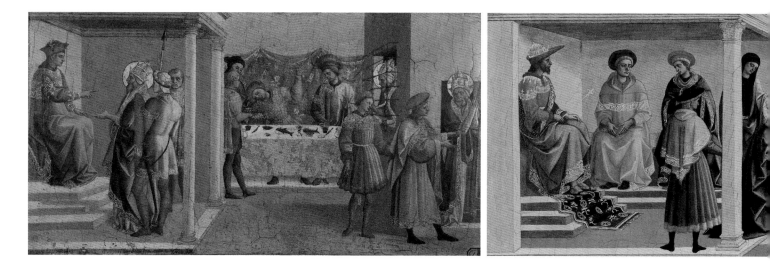

Fig. 3 *Miracles of Saint Sylvester*, about 1450–3
Egg tempera on wood

Sylvester predicts the Death of Tarquinius from choking on a Fishbone and is liberated from Prison, 30.5 × 58 cm
Doria Pamphilj Collection, Rome

Sylvester brings a Bull Back to Life, 31 × 78.4 cm
Worcester Art Museum, Worcester, MA
Museum Purchase, 1916.12 (cat. 5)

Sylvester resurrects Two Priests killed by a Dragon, closing its Mouth with the Sign of the Cross, 30.5 × 58.5 cm
Doria Pamphilj Collection, Rome

hand–eye coordination, guiding a sharp tool into making marks of a precise length and depth. Since the pointed tip of the stylus was used like a writing instrument, chasing cast bronze with it would have offered useful practice for any artist hoping to hone his drawing abilities on paper, with metalpoint or even in pen and ink.

Among other work, Pesellino found a job in the city's leading workshop, run by the perpetually overburdened Carmelite friar and painter, Fra Filippo Lippi. During the late 1430s and early 1440s, Lippi accepted at least five major altarpiece commissions, in addition to producing portraits, smaller devotional and furniture paintings and other special projects. He frequently left the intricate predella, which served as the base of an altarpiece, to other painters in his employ and indeed Pesellino's earliest surviving painting is a predella for Lippi's altarpiece for the Novitiate Chapel at Santa Croce (fig. 2, see cat. 1), a building complex already complete in 1439 that Cosimo 'Il Vecchio' de' Medici himself had financed.[9] Cosimo's involvement may have helped secure Pesellino's employment by Lippi, a painter close to the family.

Lippi's ad hoc workshop arrangements varied widely by project and individual experience. If Lippi subcontracted this predella to Pesellino, then the young painter probably served as an associate or *discepolo*, rather than an apprentice in the traditional sense. This type of work suggests that Pesellino was aiming high, setting his sights on learning how to produce a novel altarpiece format – the single rectangular field or *tavola quadrata* – in one of the shops that had perfected it. Predella imagery was rarely subject to restrictive contractual clauses, offering a young painter an unusual opportunity to invent, and Pesellino painted at least one more, now divided between Rome and Worcester, MA (fig. 3, see cat. 5). He would not have been paid much for either – perhaps only a few florins – but the true value lay in the chance to establish his reputation.

By 1442, something had paid off in Pesellino's career. In his marriage contract, Pesellino is a *pictore*, or independent painter, sufficiently financially secure to marry (at an unusually young age) and promise a dowry of 100 florins.[10] The elite reputation of his grandfather Pesello – which persisted decades after his death – no doubt accelerated recognition and success for the painter styled as his heir.[11] Pesellino, at age 20, was already garnering support from scions of the powerful Corsi, Guidetti and Altoviti families, who witnessed the dowry contract.[12] While it probably took longer for Pesellino to establish his own workshop, he turned to small-scale, devotional paintings for prestigious clients to advance his career.

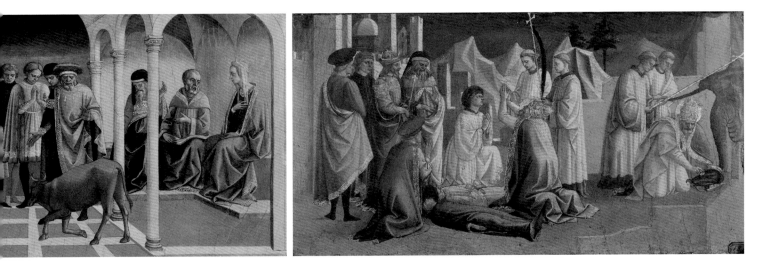

SMALL DEVOTIONAL PAINTINGS

An exceptional painting from this period around 1445 is the jewel-like *Annunciation* (cat. 4). The intimate scale, which showcases Pesellino's refined, miniaturist technique, would have appealed to its probable patron, the book collector Bernardo di Bartolomeo Gherardo Gherardi. This wealthy Florentine patrician and Medici ally – and colleague of Cosimo de' Medici on the board of works of Florence's city hall – lived in the district of Santa Croce and would have known the artist's predella for the Novitiate Chapel.

As an ambassador, Bartolomeo often represented the Florentine state to an international elite and may have commissioned the deluxe presentation manuscript of *The Second Punic War* by Silius Italicus as a diplomatic gift for the bibliophile pope Nicholas V near the time of his election in 1447. The book was a collaboration between Pesellino and his Florentine colleague Zanobi Strozzi. Pesellino painted the lion's share, seven lavishly coloured, full-page, single-figure miniatures inscribed in gold (figs 4–6). In one, a resplendent Pope Nicholas V, enthroned in a classical niche, turns to the left and gestures to the ancient author who holds a manuscript as impressive as this one.

The papal *curia* (the Vatican administration) probably rewarded Pesellino with additional work. Three notable commissions from this period include exquisite small devotional panels, *Virgin and Child Enthroned with Six Saints* (The Metropolitan Museum of Art, New York), *Virgin and Child Enthroned with Saints Jerome and John the Baptist* (Philadelphia Museum of Art) and the *Crucifixion* (Gemäldegalerie, Berlin), executed on gold grounds that were then going rapidly out of fashion in Florence (figs 7–9). The first two paintings may have been made for a cardinal, or in memory of one. In both, Pesellino dresses Jerome in scarlet cardinal's robes in the place of honour at the Virgin Mary's right. In the New York picture, his marvellously foreshortened right foot draws attention to the *galero*, a cardinal's ceremonial headgear, resting nearby and casting a shadow on the plinth (also a feature of the Philadelphia painting). The tassels fan out and entwine with a wreath of flowers lying like an offering at the Virgin's feet. According to custom, the *galero* was hung over a cardinal's tomb until it disintegrated, symbolising the passage of earthly glory.

The resplendently garbed male saints – in particular Augustine and an armoured young warrior who might be Theodore, patron saint of Venice – together with the memorial-like wreath raise the possibility that this painting was made for the Venetian Augustinian canon Antonio Correr (died 1445). Cardinal bishop of Ostia and Velletri

Fig. 4 *Pope Nicholas V*, 1447
Inscribed: NICCOLAVS Vˢ PONTIFEX MAXI[M]VS
Pen and ink, coloured pigment (tempera?)
and gold on vellum, 32.9 × 19.4 cm
State Hermitage Museum, St Petersburg, inv. N53

Fig. 5 *Allegory of Carthage,*
1447
Pen and ink, coloured
pigment (tempera?) and gold
on vellum, 28.8 × 20.2 cm
State Hermitage Museum,
St Petersburg, inv. N51

Fig. 6 *Allegory of Rome,*
1447
Pen and ink, coloured
pigment (tempera?) and gold
on vellum, 28.8 × 20.2 cm
State Hermitage Museum,
St Petersburg, inv. N52

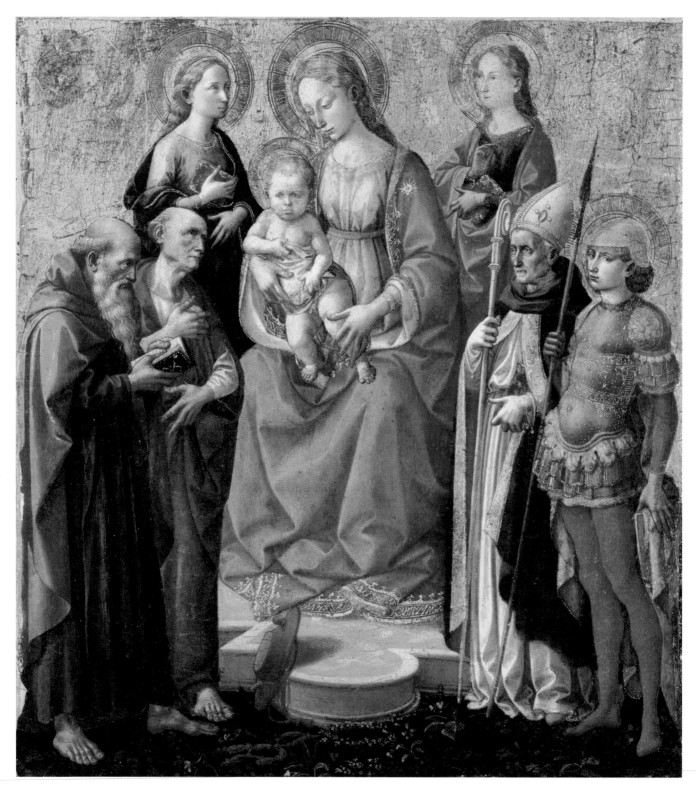

Fig. 7 *Virgin and Child Enthroned with Six Saints*, about 1445–50
Egg tempera on wood, 22.5 × 20.3 cm
The Metropolitan Museum of Art, New York
Bequest of Mary Stillman Harkness, 1950

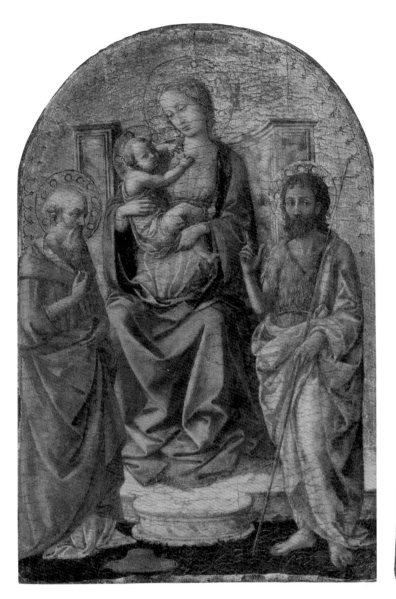

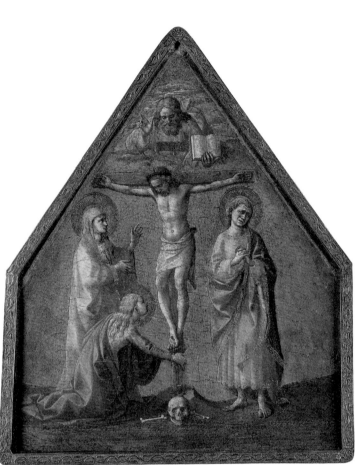

and dean of the college of cardinals, Correr owned at least one other painting attributed to Pesellino's workshop, a *Coronation of the Virgin* that bears his *impresa* (insignia).[13] Correr's possession of the New York panel would also account for the presence of at least one of the two virgin martyr saints, who could be Aurea, the titular (dedicatee) of Ostia's cathedral and the seat of his cardinalate. Ownership by a prince of the church may also help to explain the abundance of gold, not only in the background – where it was finely tooled into haloes – but drawn through the Virgin's cloak hem into small cartouches bearing pseudo-inscriptions, across the armour of the warrior saint and studding the covers of the miniature manuscripts that four of the saints hold.

To design in such exacting detail required drawings of the kind typically reserved for monumental altarpieces. He probably studied each tiny figure multiple times, as evidenced by the highly finished drawing in the Louvre of the bishop saint (cat. 3). Both the New York and Philadelphia paintings reveal meticulous underdrawings distinguished by few changes and minuscule hatching to indicate shadows in draperies.[14] Pesellino's surviving works on paper point to his practice of finalising his compositions in advance before transferring the design to panel with cartoons.

Fig. 8 *Virgin and Child Enthroned with Saints Jerome and John the Baptist*, about 1448
Egg tempera on wood, 30.8 × 21 cm
Philadelphia Museum of Art
John G. Johnson Collection, 1917

Fig. 9 *Crucifixion with God the Father, Saints John, Mary Magdalene and the Virgin*, mid-1440s
Egg tempera on wood, 18.5 × 15 cm
Staatliche Museen zu Berlin, Gemäldegalerie

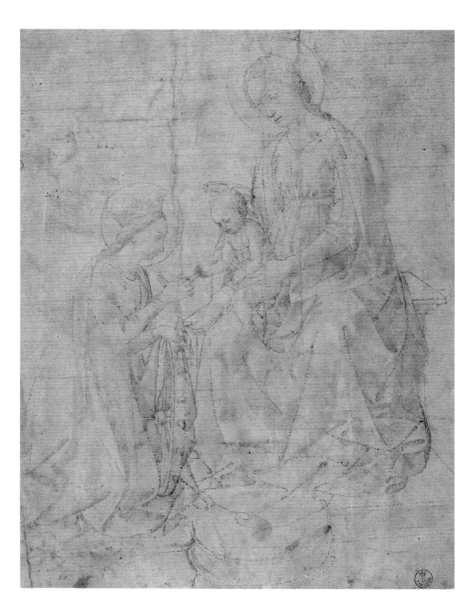

His *Seated Christ* and *Mystic Marriage of Saint Catherine* (fig. 10) (both Gallerie degli
Uffizi, Florence) may even be the earliest extant cartoons for Renaissance panel
paintings.[15] Both were pricked for transfer in the finest details including the latter's
masterfully foreshortened spokes on the saint's wheel and Christ's tiny fingers. Pesellino's
painting made from his *Mystic Marriage* cartoon does not survive, but imitations of it
(Strossmayer Gallery, Zagreb, and private collection) by an artist who closely followed
the originals by Lippi and Pesellino suggest that the completed painting was owned
by a client esteemed enough to command emulation (see p. 41).[16]

Ownership of Pesellino's small-scale works – paintings and manuscripts – points to
his reputation in Florence as a 'proto' connoisseur's painter, even after his death. In the
second half of the fifteenth century, the wealthy Florentine merchant Francesco del
Pugliese decorated the private chapel of his country estate of Sommaia, outside Florence,
with exquisite small-scale devotional paintings by Pesellino, Sandro Botticelli and Filippino
Lippi.[17] The installation of his chapel as a quasi-gallery of Florentine painting juxtaposed
several generations of artistic talent that would have been appreciated as much by
cultivated viewers familiar with the city's leading artists – past and present – as by pious

worshippers. Del Pugliese, like Cosimo de' Medici and Nicholas V before him, exemplifies this emerging class of patrons referred to as 'uomini intendenti', men familiar with the art of painting, able to discriminate between styles and who took pleasure in doing so.

Another intriguing example suggestive of this burgeoning connoisseurship is a painting recorded in the 1512 copy of the 1492 Medici inventory:[18] 'a picture with a gold frame, painted with a Saint Jerome and a Saint Francis by the hand of Pesello [Pesellino] and Fra Filippo [Lippi]'.[19] The double attribution may have come from an inscription on the now lost frame. Several scholars have identified the picture with a panel in the Lindenau Museum in Altenburg, Germany (fig. 11).[20] Its prominent rock outcrop that partially conceals a fifteenth-century church appears to evoke the 'Sasso Grosso' of Fiesole, a signal geological feature on the hill separating the villa of Giovanni di Cosimo de' Medici from the tiny convent church of San Girolamo, both buildings financed by the Medici and featured together in other fifteenth-century paintings.[21] The patron may well have asked that the friar in the foreground be a Hieronymite in a grey habit, as he was depicted in a contemporaneous copy.[22] Like Pesellino's lost *Mystic Marriage of Saint Catherine*, as well as several paintings by Lippi owned by the Medici, this panel was also reproduced by a single workshop specialising in imitations, further suggestive of its rarity and importance (see pp. 38–41).

Assuming the picture owned by the Medici was the product of a collaboration between Pesellino and Lippi, how might this joint venture have worked in practical terms? Perhaps one artist provided the drawing while the other painted. Or one artist designed and painted a section while the other completed it. Without technical evidence, it remains difficult to discern, especially given the painting's seamless finish. However, its style, which appears relatively consistent with that of Lippi, raises the possibility that Pesellino furnished a drawing for part or all of the composition and Lippi executed the panel to his design. Unusually, the design features two lions, male and female, not typical of Jerome's iconography. Lions were signature elements of Pesellino's later works – including a lost Palazzo Medici overdoor painting (discussed further below), the David panels (cat. 6) and the altarpiece for the Church of the Holy Trinity in Pistoia (cat. 8). The unusual compositional features, potential Medici provenance and possible collaboration on such a small scale support the interpretation that this picture was valued as much for artistic accomplishment as devotional function, like the Del Pugliese pictures.

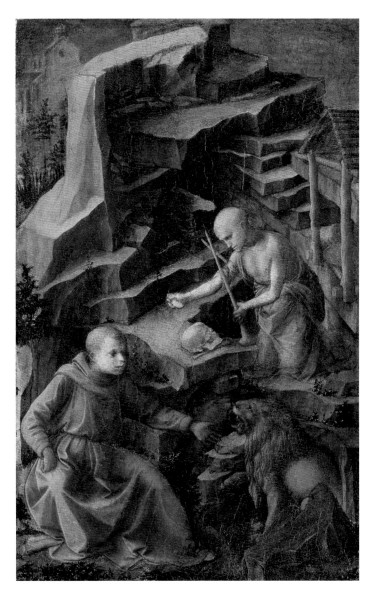

Fig. 11 Francesco Pesellino (1422–1457) and Fra Filippo Lippi (about 1406–1469) *Saint Jerome in the Wilderness with a Friar and Two Lions*, early 1450s Egg tempera on wood, 46.7 × 29.9 cm Lindenau Museum, Altenburg

DOMESTIC FURNITURE PAINTINGS

Animals were a hallmark of Pesellino's mature domestic paintings. According to fifteenth- and sixteenth-century sources, he developed a singular reputation for animal painting (see pp. 29–30) and nowhere is that talent more clearly reflected than in *The Story of David and Goliath* and *The Triumph of David* (cat. 6).[23] At least seventy-eight

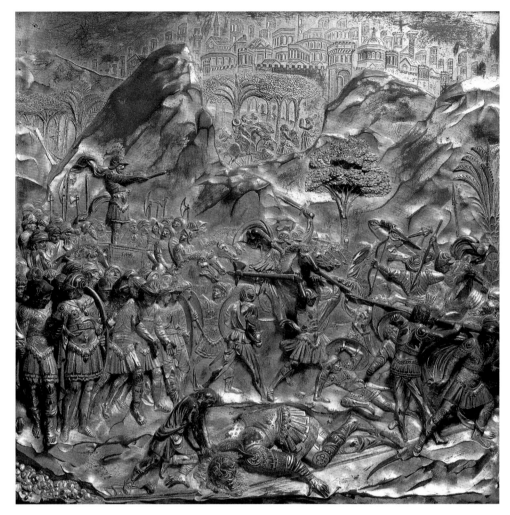

horses fill the two panels,[24] as well as a variety of flocks (goats, sheep and oxen) and also animals associated with the hunt, including a stag, deer, rabbits, falcons, a leopard, dogs and lions.[25] The poses of each animal – in profile, three-quarter view, from behind and foreshortened – resound with technical accomplishment, underpinned by drawings as precisely designed and modelled as those of the figure of the protagonist, David.

Proposed dates for Pesellino's David paintings range from the late 1440s to 1455, but this can be narrowed down to between 1452 and 1455.[26] Pesellino clearly took inspiration from Ghiberti's relief depicting David and Goliath for the east doors of the Baptistry, completed and installed in 1452 (fig. 12). He also reused a common figure type in the David panels and his *Trinity with Saints* for the Pistoia Altarpiece (1455–7, cat. 8). David and Saint Mamas are clothed in practically identical costumes. Pesellino not only conceived the drawn study for Saint Mamas (about 1455, see fig. 51)[27] on a similar scale to the figure of David, but he adapted its posture to the triumphant figure of David holding the head of Goliath. The stylistic similarities between the two figures, in addition to the artist's experimentation with a complex landscape element, suggest a date for the David panels between 1452 and 1455, after Ghiberti's relief became a public monument and before the Pistoia Altarpiece was commissioned.

By the time he painted the David stories, Pesellino had been producing domestic furniture paintings for several years. In the later 1440s and early 1450s, he made several pairs of paintings designed to decorate *cassoni* (grand wooden chests, often intended

to contain a bride and groom's wedding trousseau) including Boccaccio's *Story of Griselda* (Accademia Carrara, Bergamo, see fig. 15), the *Seven Virtues* and *Seven Liberal Arts* (Birmingham Museum of Art, Birmingham, AL) and Petrarch's *Triumphs of Love, Chastity and Death* and *Triumphs of Fame, Time and Eternity* (Isabella Stewart Gardner Museum, Boston, see fig. 14). The latter pair stand out both for their subject – the earliest known cassoni depicting Petrarch's *Triumphs* – as well as for their execution. Like the David panels, and smaller devotional paintings before them, they reveal an unusually painstaking preparation in the design phase. Pesellino created fully resolved underdrawings for many figures, even sketching a nude armature beneath some of the clothed men.

The 1450s marked a moment of new potential in the realm of domestic painting in Florence and Pesellino emerged as a go-to painter for deluxe domestic furnishings with novel subject matter.[28] Documents record Pesellino's lost overdoors and *spalliere* – a new style of furnishing painted on canvas or wood and mounted at shoulder (*spalla*) height – for important Florentine palaces. The 1492 Palazzo Medici inventory describes a remarkable room with more than one unique painting by Pesellino. In the *sala grande*, installed above a spalliera of inlaid wood (*intarsia*), the inventorist recorded an overdoor on canvas depicting lions in a cage by Pesellino, pendant to a larger painting of a figure of Saint John the Baptist by Andrea del Castagno.[29] Both pendant canvas overdoors reinterpreted civic emblems for an unprecedented decorative scheme that reflected the audience hall of a public building – rather than a private family palace – in the arrangement of its decorations as well as their subjects.[30] Pesellino had grown up in a workshop that produced heraldic banners, often with animal imagery, and would have been uniquely well equipped to design lions with an emblematic connotation and to execute them on a cloth support.

Another canvas by Pesellino was located in the large ground-floor room (*camera grande terrena*) of Lorenzo de' Medici, called 'Il Magnifico'. It depicted a hunt scene and was described as part of an arrangement of six paintings installed above an intarsiated wood spalliera. The other five paintings were by Uccello: three of the Battle of San Romano, a fourth of a battle between dragons and lions, and a fifth depicting the story of Paris.[31] Only the San Romano panels survive.[32] They were not originally made for the ground-floor bedchamber that they occupied in 1492, but were requisitioned by Lorenzo de' Medici from the Bartolini Salimbeni family villa for his own use. The other three paintings, including that by Pesellino, probably belonged to the Medici from the outset.[33]

ALTARPIECES

By the mid-1450s, Pesellino was operating a successful workshop diversified in different fields. They included small-scale devotional paintings and domestic furnishings as well as half-length paintings of the Virgin and Child (cat. 7, see also pp. 38–41) and monumental altarpieces. Pesellino's 1453 profit-sharing partnership (*compagnia*) with two lesser-known painters, one a specialist in domestic furniture painting and the other in *stemme* (heraldry), may reflect both the economic goal of splitting costs and reducing the risk of potential market fluctuations, as well as the desire to benefit from specialist expertise.[34] Four months after signing the partnership, on 8 December 1453 Pesellino's mother and aunt jointly sold their rights to Pesello's workshop to one of the partners, Piero di Lorenzo Pratese, for 35 florins. Pesellino was clearly content for the family to dispose of this property to his new business associate, indicating that a workshop fitted out for the production of large banners did not suit his aspiration to pursue altarpiece commissions.

Pesellino was taking his first steps in this field. The *tavola quadrata* altarpiece required lengthy contracts, multiple stages of drawings – from approval sketches to

compositional designs and underdrawings – and its painted components often included a predella, pilasters and pinnacles. The *Virgin and Child Enthroned with Saints* in the Louvre (fig. 13) is his earliest surviving *tavola quadrata* and probably a first foray into the field of monumental altarpieces. Its design shows Pesellino diligently confronting the challenges posed by the format and figural design at this scale. He took as his starting point an existing composition of his own of the *Virgin and Child in a Landscape* dating from around the same period of the early 1450s (Alana Collection, Delaware), discarding the landscape and enlarging the Virgin and Christ, a dramatic change of context and size that may explain in part the altarpiece's cramped layout. Pesellino also struggled with the composition. From technical analysis we know that he significantly revised the setting at a relatively late stage in the process, replacing a three-column arcade with the architectural enclosure visible today.[35]

By contrast, Pesellino's adjustments to the design of individual figures were relatively minor, if exacting. Most notably, a surviving preparatory drawing for the bishop saint – possibly Zenobius (see figs 37, 38) – shows that Pesellino modified the profile at each stage of its execution on paper, incision, underdrawing and in the paint layer which overlaps with his gilded halo.[36] Pesellino borrowed the composition of this saint and his location from a triptych of the *Virgin and Child with Four Saints* by Lippi (Accademia Albertina di Belle Arti, Turin, and The Metropolitan Museum of Art, New York) which on stylistic grounds can be dated to the late 1430s or early 1440s.[37] As earlier in his career, Pesellino was looking closely at Lippi's models, also designing an enclosure that recalls the same feature in Lippi's overdoors and altarpieces.

No patron has ever been identified for this altarpiece. The figures of Saint John the Baptist in the position of honour, as well as a bishop saint (possibly Zenobius), point to a Florentine context. A fifteenth-century imitation located in the mountainous Casentino region suggests that Pesellino may have made the original for a provincial church nearby.[38] Notably, Pesellino's altarpiece shares stylistic and compositional similarities – in its views of the distant forest and trees – with the two overdoors by Lippi made for Palazzo Medici.[39] Like the angel Gabriel in the *Annunciation*, red dots line Saint John's cloak and cover Christ's cushion. Given the patronage of both overdoors, it remains possible that this altarpiece was also made for a Medici family member.

Whatever the circumstances of that commission, the Medici were certainly involved in Pesellino's second surviving altarpiece, *The Trinity with Saints* (cat. 8). In 1455, a confraternity of priests from Pistoia decided to commission an altarpiece. They agreed to spend 150–200 florins, a substantial sum appropriate to the honour they required it to reflect. The amount the priests settled on indicates that, from the outset, they were in the market for a leading talent from Florence. They settled on Pesellino probably thanks to the intervention of their ultimate superior, Bishop Donato de' Medici (1407–1474), who promoted his family's preferred artists (see p. 66).

Pesellino's drawings played a key role in communicating with his out-of-town patrons. His celebrated grasp of *disegno* served him well, enabling the painter to avoid the pitfalls of his first altarpiece and resolve various challenges. The most technically complex pictorial elements – from depicting a miraculous vision to designing hovering angels – suggest that Pesellino was familiar with the work of Andrea del Castagno. While Vasari claimed, impossibly, that Castagno was Pesello's teacher, they certainly collaborated and Castagno may well have had a hand in Pesellino's training.[40] His techniques also resonate with lessons probably learned from his grandfather as well as Lippi. In choosing Pesellino and then Lippi to finish his work, the priests sought to align themselves with Medici interests. Furthermore, the extraordinary compatibility of Lippi's technique with Pesellino's design assured the success of the project even though the altar furnishings took ten years to complete.

Pesellino would never see this, probably his most lucrative commission, to completion. On 29 July 1457, when once again the sweltering heat of summer had brought plague to Florence's streets, Pesellino died suddenly, leaving behind his wife and family. The task of completing the altarpiece went to his one-time collaborator, Lippi. So it was that Pesellino's career began and ended with prestigious, Medici-backed altarpiece commissions undertaken in collaboration with the great Carmelite painter.

Pesellino's small but impressive oeuvre exercised an outsize influence on the next generation of painters in Florence (see pp. 37–41). Perhaps his most enduring legacy – and the one which drew them to his work – was an artistic approach characterised by skilful design. The painted products of *disegno*, executed on wood panel, canvas or vellum, were not intrinsically valuable but manifested artistic virtuosity and intellectual excellence, as much indicative of prodigious talent as the ability of a refined patron to identify it. Piero de' Medici bequeathed this taste to his son Lorenzo and it became the hallmark of elite local workshops, giving rise to Verrocchio and the Pollaiuolo brothers of the 1470s, the Florentine *maestri di disegni* who transformed drawing from a mere tool into an increasingly powerful form of cultural currency.

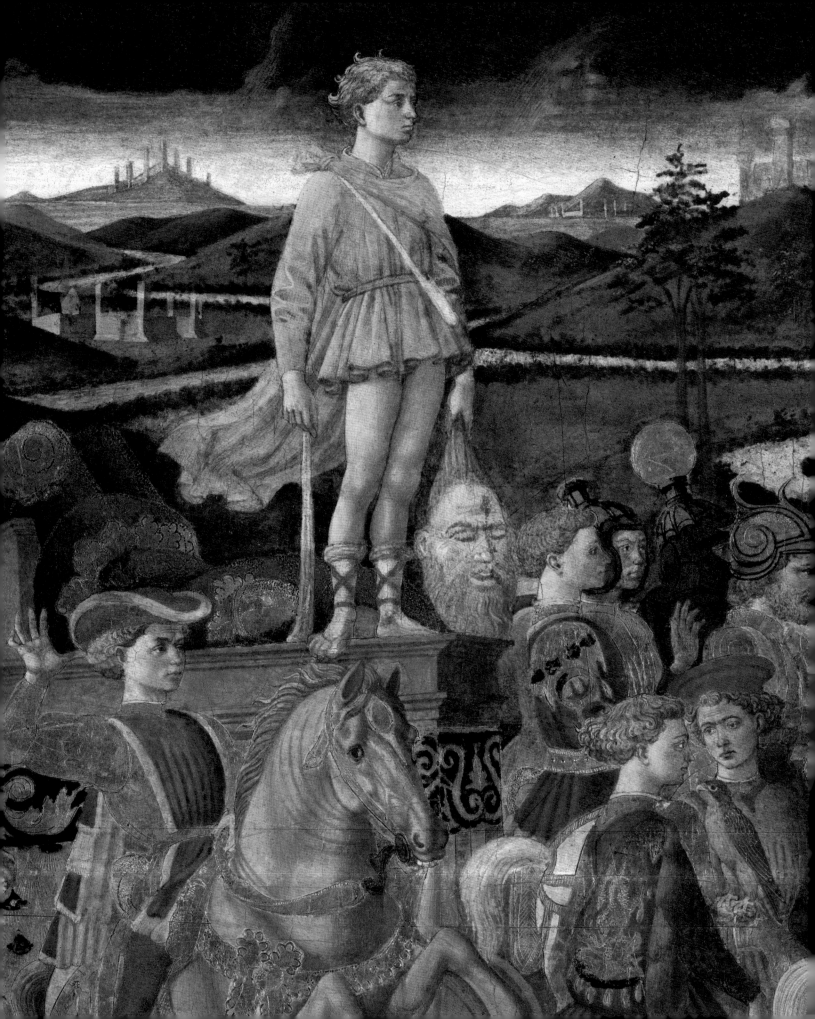

Pesellino and the Medici palace

The *Stories of David* panels: a reappraisal

LAURA LLEWELLYN

IT has been fifty years since the *Stories of David* panels first went on display at the National Gallery, initially as a long-term loan and later a momentous addition to the museum's collection of early Italian paintings. The two panels depict part of the story of the shepherd boy David, as told in the Old Testament (1 Samuel 17–18). The first shows his famous defeat of the giant Goliath, and the second the triumphant return of the Israelite army to Jerusalem. The recent conservation treatment of the two panels has provided the opportunity for new, in-depth study and a reassessment of their historical significance, as well as their likely provenance and original function (see also cat. 6).

The earliest record of the David panels locates them in a palace belonging to the Pazzi family on borgo Albizi in 1821, where each is described as a 'cassone' with a red frame decorated with gold.[1] They later passed into the collection of Marchese Luigi Torrigiani, where they were recorded in 1869 as 'frontal panels of a cassone', and in 1884 as 'two beautiful chest panels, known as cassoni'.[2] Although there is no known record of these two paintings prior to the nineteenth century, we can infer from visual, physical and contextual evidence that they were intended for domestic display.

In the second of the two panels, the *Triumph*, the procession culminates in a meeting between the men at the head of the cavalcade and a group of finely dressed women at the city gates. This encounter has typically been understood as a wedding scene.[3] Disregarding for the time being the question of whether or not this is the case, the panels' subject matter – a battle paired with a triumphal procession – points to their probable original location in a marital chamber.[4] Moreover, the panels' long, horizontal format strongly suggests, as indeed the nineteenth-century records insist, that they were originally the fronts of cassoni.[5] The cleaning of the panels, as part of the restoration campaign, revealed clear evidence of the lower parts of old keyholes at the upper edge of each panel (see p. 59). In addition, damage to the paint surface at the centre of each was apparently caused by keys dangling in the locks of the original chests, subjecting the painted surface to small knocks and dents (see fig. 47), thereby also revealing the early insertion of the pictures into lockable chests.[6] We know that cassoni were among the range of painted objects that Pesellino produced, both from descriptions of lost works and from numerous physical survivals. These include his Petrarchan *Triumphs* (Boston, fig. 14) and the *Stories of Griselda* (Bergamo, fig. 15), with the possible addition of the *Seven Virtues* and the *Seven Liberal Arts* (Birmingham, AL) which have been variously attributed to Pesellino or a follower or collaborator.[7]

The David panels' exceptionally high quality – both in terms of design and technical execution – together with their unusually long length, has led some scholars to conjecture that they may not have been cassone fronts but are in fact early examples of *spalliere,* wooden panels inserted at shoulder height into the wainscoting of a bedchamber, or 'camera' (see pp. 34–5).[8] Certainly, Pesellino was a painter of spalliere, apparently one of Florence's earliest. This is attested to by two early sixteenth-century accounts describing a 'spalliera' with many animals (now lost) that he made for the old Medici residence on via Larga (the *casa vecchia*), occupied from the mid-1450s

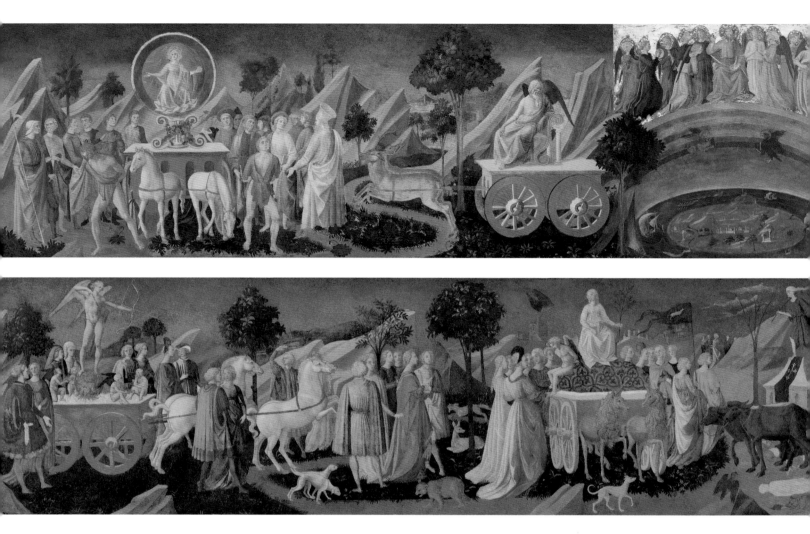

Fig. 14 *The Triumphs of Fame, Time and Eternity* and *The Triumphs of Love, Chastity and Death*, about 1450
Egg tempera on wood, 42.5 × 158.1 and 45.4 × 157.4 cm
Isabella Stewart Gardner Museum, Boston

by Cosimo il Vecchio's nephew, Pierfrancesco.[9] These accounts of the *casa vecchia* spalliera seem to be the source for the 'spalliera di animali, molto bella' in the house of the Medici that Vasari mentions in his *vita* for Pesellino. The suggestion that the David panels were made as spalliere is undermined, however, by the physical damage (typically associated with a keyhole and keys) already noted. It is significant too that these panels were described in all the nineteenth-century records as panels from cassoni. The sophisticated receding landscape is another feature of the David panels which has been cited as evidence that they cannot have been intended to be displayed at knee height, but were designed to be viewed at eye level or higher. However, the foot soldiers engaged in hand-to-hand combat in the middle distance are shown tucked behind the frenzied battle scenes in the foreground, rather than at a higher vantage point (as, for example, the soldiers in the distance in Uccello's *Battle of San Romano*). This masterful placement of the background figures supports an original viewing point from above. Also in favour of their identification as cassoni is the fact that the various derivations and copies of Pesellino's David panels that appeared in the decades after his death take the form of cassone panels (on these later derivations, see pp. 42–3).[10]

Observations regarding the unusual size and quality of the panels are nonetheless valid and require some interrogation. The height of the panels is within the standard for contemporary cassoni, and though their length is fairly unusual,[11] it is not exceptional. Other cassone panels of a comparable size from later in the century survive.[12] Rather

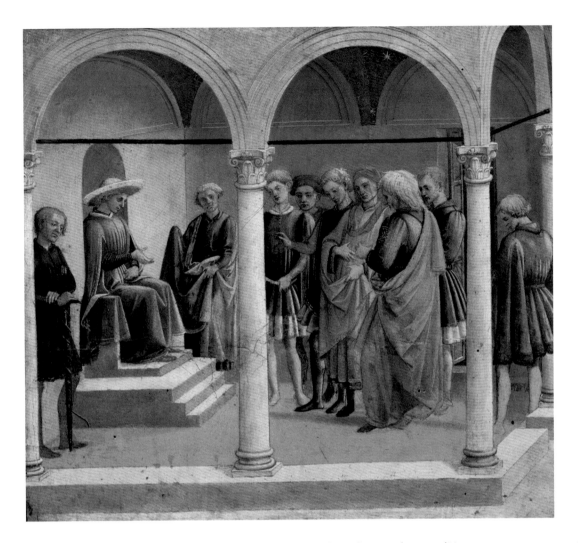

Fig. 15 *Episode from the Story of Griselda*, 1445–50
Egg tempera on wood, 43 × 49 cm
Accademia Carrara, Bergamo

than point away from their function as chest frontals, might these distinguishing qualities instead indicate the prestige and importance of these particular chests and their patrons?

Shortly after the acquisition of the panels by the National Gallery in 2000, Francis Ames-Lewis developed an existing hypothesis regarding their possible Medici provenance.[13] His argument was based in large part on the preponderance of apparently Medicean devices throughout the paintings' imagery. He noted that the three feathers in the helmet plumes of the Israelite soldiers – some with traces of red, white and brown paint (he rightly speculated that the brown is an oxidised green) – were comparable to the three feathers in these colours in the Medici family emblem (see figs 19, 45), drawing parallels with the illuminated imagery in Piero di Cosimo's personal manuscripts. Ames-Lewis also highlighted the *torchio* on the livery of a number of foot soldiers in Saul's army (fig. 16), a device which recalls the distinctive torch-holder still visible today on the south-east corner of the Medici palace, and which reappears on the martingale of the donkey ridden by Cosimo il Vecchio in Benozzo Gozzoli's *Procession of the Magi* chapel frescoes (fig. 17). The uniforms of the foot soldiers, with some panels of fabric showing interlocking rays in red and white, reflect the colours of Florentine civic heraldry that was being appropriated by the Medici family during this period. Lions too, held in cages in the Loggia dei Lanzi outside the seat of the Florentine government, the Palazzo della Signoria, were another Florentine symbol that the Medici family seems to have incorporated repeatedly into the artistic programme of their new palace, including

Figs 16, 17 Details showing
the *torchio* motif on a soldier's
livery in the *Battle* (cat. 6) and
on the donkey's martingale in
Benozzo Gozzoli
(about 1421–1497)
The Procession of the Magi, 1459
Fresco
Palazzo Medici Riccardi, Florence

Figs 18, 19 Details showing
a preying falcon in Benozzo
Gozzoli's *The Procession of
the Magi* and a golden falcon
in the *Battle* (cat. 6)

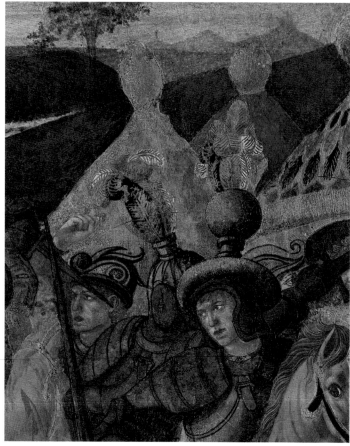

an overdoor by Pesellino himself showing lions behind a grate (see p. 21).[14] And, perhaps most famously, the figure of David himself – a potent symbol of virtue's triumph over tyranny – was the civic emblem for the city of Florence whose image was put to the service of Medicean visual propaganda most consistently and most publicly by Cosimo and his heirs.[15]

Finally, Ames-Lewis observed the repeated appearance of a bird of prey (a falcon), the creature which Piero di Cosimo used as his personal emblem with growing frequency during this period.[16] These depictions range from birds in their natural habitat, perched in trees or on the ground, or swooping for prey, to heraldic devices, such as the golden falcon perched on the leftmost tent behind the battling adversaries (fig. 19). In the *Triumph* they appear again, now tamed, alert and majestic on the forearms of the processing soldiers (see details on pp. 24 and 33). The intended correlation between the living animals and the heraldic ones is made plain by the echoing of forms in both. For example, the swooping bird in the scene of David with his flocks is repeated on the embroidered cape of a member of David's triumphant entourage in the neighbouring panel. The preying falcon was another feature of Pesellino's panels to reappear in Benozzo's chapel frescoes (fig. 18). While Piero was not alone in using falcon heraldry during the period – both the Strozzi family and the Calimala guild displayed a falcon on their *stemma* (crest) – this tendency to bring the creature to life in painted form does seem to be a particular feature of Piero's patronage.

Beyond individual symbols, devices and heraldry, Ames-Lewis rightly observed how Pesellino's treatment of the natural world finds parallels in some of the most sophisticated works of art commissioned by the Medici, and Piero in particular, at this date. Notably, he appears to have been intimately familiar with Domenico Veneziano's tondo now in Berlin (fig. 20). Such was Pesellino's debt to this masterpiece – its sweeping landscape, the animals and the sumptuously attired company (among whom Piero appears with a falcon on his arm) – that the compiler of the 1492 Medici inventory later attributed it to Pesellino himself.[17]

Pesellino's skill as a painter of animals is amply demonstrated in the David panels (see pp. 19–20).[18] Varied and abundant, they populate the wilderness where David tends his flocks, and embody David and Goliath's reciprocated threat to feed each other's flesh to 'the fowls of the air, and … the wild beasts of the earth'. However, in their number and careful depiction, the animals also seem to have been included for their inherent visual appeal in a manner that recalls the tastes of courtly patrons in northern Italy that Piero evidently admired and sought to emulate. Indeed, while many reflect the artist's observations from life, others reveal a possible knowledge of the drawings of Pisanello (fig. 21), and others still a reliance on model books.[19]

The depiction of animals is also compatible with the type of imagery that we know was commissioned from Pesellino, presumably in the 1450s, by the Medici to decorate their newly constructed palace. The 1492 inventory of the Palazzo Medici describes a panel by the hand of Pesellino depicting a hunt ('una chaccia') in Lorenzo's chamber, the *camera grande terrena*, comparable in scale, we assume, to Uccello's *Battle of San Romano* panels installed nearby. It also lists the overdoor painting by Pesellino showing caged lions in the *sala grande*. In the following century, Vasari's description of Pesellino's Medici commissions also highlights the strength of his renown as a painter of animals:

Fig. 20 Domenico Veneziano (1410–1461)
The Adoration of the Magi, about 1440
Egg tempera on wood, diameter 90 cm
Staatliche Museen zu Berlin, Gemäldegalerie

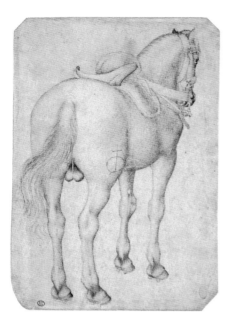

Fig. 21 Pisanello (about 1380/95 – about 1450/55)
Study of a Horse: Saddled Stallion from the Rear,
mid-fifteenth century
Pen and brown ink on paper, 20 × 16.5 cm
Musée du Louvre, Paris, INV 2378 (recto)

in the house of the Medici he adorned a spalliera very beautifully with animals and certain bodies of cassoni with little scenes of jousts on horseback. And in the same house there are seen to this day some canvases by his hand, with lions looking out from behind bars, which appear absolutely alive; and he made others outside, with one fighting with a serpent; and on another canvas he painted an ox, a fox, and other animals, very alert and lifelike.[20]

Scholars have surmised that Vasari's description of these 'bodies of cassoni with little stories of jousts on horseback' could not refer to the David panels. Had he seen them, Vasari would surely have recognised our paintings as depictions of the Old Testament story of David, and not mistaken them for jousts.[21] However, a closer reading of his text may indicate that Vasari never actually saw the cassoni in question. We have already observed how he lifted the reference to the *casa vecchia* spalliera from earlier written sources.[22] Crucially, he declares in the following sentence that canvases showing the caged lions 'are seen to this day'. The implication is that the works mentioned in the previous sentence are *not* still visible. If Vasari only knew of cassoni by Pesellino once in Medici possession by reputation, but had never actually seen them, he might indeed have mistaken their subject matter. It is certainly telling that the chief detail from the 'storiette piccole' to be recalled in his account is 'giostre di cavalli'.[23] The horses, in all their diversity of pose and attitude, are arguably the most noteworthy recurring feature of the two David panels. By the time Vasari was researching and publishing the first edition of his *Vite* in the mid-sixteenth century, the Medici palace had undergone significant upheavals; much of the collection was dispersed and the branch of the family now ruling Florence, that of Grand Duke Cosimo, had moved to the Palazzo della Signoria.[24] It would not therefore be surprising for Vasari to have only indirect knowledge of cassoni by Pesellino once in that palace which were no longer visible.[25] What is striking though is that these chests do not appear in the list of works by the painter, or other painted chests, in the 1492 inventory, which suggests that, if indeed they were originally there, they had been removed at an earlier point in the fifteenth century.

Cassoni were typically commissioned on the occasion of a wedding (though not all painted wooden chests in the Florentine household were marriage chests).[26] Piero de' Medici married Lucrezia Tornabuoni in 1444. Stylistically speaking, it seems highly improbable that the David panels were made at this early date in Pesellino's career.[27] Indeed, the stylistic gulf between the *Stories of David* and Pesellino's evidently earlier scenes from the life of David today in Le Mans, Cambridge (MA) and Kansas City seems to discount the proposal that they once belonged to the same cassone (see also p. 34).[28] Moreover, several scholars have proposed that Pesellino's Petrarchan *Triumphs* in Boston (fig. 14) may be identified as the pair of unattributed chests, depicting the *Triumphs* of Petrarch, described in the 1492 Medici inventory,[29] with some inferring that these were made for Piero's marriage to Lucrezia.[30] This suggestion is persuasive not least because of the works' stylistic qualities, which invite comparison with the Novitiate predella (cat. 1, see fig. 2) and so point to Pesellino's youthful phase. Moreover, the measurements provided in the 1492 inventory – three and a half Florentine *braccia* – indicate chests just over two metres long.[31] The dimensions of the Boston panels, each measuring just under 160 centimetres in length, certainly correspond to the inventory record when allowing for lost framing elements at the corners of the chest. Finally, the Petrarchan subject matter is wholly aligned to Piero's documented interest in Petrarch in the 1440s. A letter to Piero from the illuminator and medallist Matteo de' Pasti indicates that around 1441, when Piero was beginning to form his library, he commissioned an illuminated manuscript of Petrarch's *Triumphs*.[32] Such a volume later appears in the Medici inventories of 1456 and 1464.[33] Furthermore, in about 1448, on the occasion of the birth of his first son, Lorenzo,

Piero commissioned a birth tray (*desco da parto*) from Lo Scheggia depicting Petrarch's *The Triumph of Fame* (fig. 22).[34] That Piero chose a Petrarchan subject to commemorate a dynastic milestone as significant as the birth of his male heir acts in favour of the possibility that he had chosen a closely related subject on the occasion of his wedding four years earlier.

If indeed the David panels were for cassoni commissioned by Piero, the question remains as to their purpose. In the second half of the fifteenth century, it became increasingly common for the groom's family to furnish cassoni at the time of a marriage, but in the first half of the century these were typically supplied by the bride's family to hold the dower goods, and this remained the case for some families throughout the period. We know that Piero provided the cassoni for the marriage of his second daughter Lucrezia (Nannina) to Bernardo Rucellai in 1466.[35] These works evidently impressed her father-in-law Giovanni Rucellai, who placed them first in the itemised list he made of Nannina's marriage gifts, describing them as very lavish ('molto ricchi'). The panels from Nannina and Bernardo's cassoni are very likely to be those found today in the Musée des Arts Décoratifs, Paris, which, like Pesellino's David panels, depict a battle and a triumph.[36] The marriage of Bianca, Piero's eldest daughter, to Guglielmo de' Pazzi might seem a plausible event for the commissioning of the David cassoni, particularly considering the later Pazzi provenance of the works. But the couple were not married until 1459, possibly later, and Pesellino was dead by 1457. Both on stylistic grounds and given his preoccupation in the final years of his life with the Pistoia Altarpiece commission, we can surmise that the David cassoni were probably made around 1452–5 (for the date see also p. 20). Nannina and Bernardo were betrothed in 1461 but did not marry until 1466. Perhaps Bianca and Guglielmo were also promised to one another several years before their union. Even so, there are no documented examples of cassoni being produced several years before the marriage they were intended to celebrate.[37] A one- or two-year lead time seems to have been more typical. For example, Pierfrancesco de' Medici ordered his wedding chests from Apollonio di Giovanni in 1455 and was married the following year.[38] Another Medici wedding to take place in the 1450s was that of Piero's brother Giovanni, who married Ginevra degli Alessandri in 1452. It seems implausible, however, that Giovanni would have commissioned panels whose imagery was littered with his elder brother's personal falcon emblem.[39]

It may be that, rather than being commissioned in connection with a wedding, these chests were made to furnish Piero and Lucrezia's brand new apartments in the newly constructed family seat, where the architectural grandeur of the new palace demanded similarly impressive works of art to furnish it. The exceptional splendour of the palace would have provided a fitting context for a pair of cassoni of unusual size and quality. We know from the accounts of visiting dignitaries, including a rhapsodic letter from Galeazzo Maria Sforza of Milan, who visited Florence in April 1459, that the palace was full of artistic treasures including tapestries, manuscripts, silverware, sculptures and, notably, 'chests of inestimable workmanship and value' ('cassoni di inextimabile manifactura e valore').[40] Could Pesellino's David cassoni have originally been commissioned by Piero as part of his campaign to furnish the magnificent new palace with works of an unprecedented quality? Then, several years later, following the demise of the esteemed painter of 'cose picchole' and with their first daughter due to be married, perhaps Piero and Lucrezia decided to gift these exceptional objects to their daughter and new son-in-law, and thus the cassoni found their way to the Pazzi palace.[41]

Fig. 22 Giovanni di Ser Giovanni Guidi, Lo Scheggia (1406–1486)
The Triumph of Fame; the Medici Tornabuoni *desco da parto*, about 1449
Egg tempera on wood, diameter 75.2 cm
The Metropolitan Museum of Art, New York
Purchase in memory of Sir John Pope-Hennessy: Rogers Fund, The Annenberg Foundation, Drue Heinz Foundation, Annette de la Renta, Mr. and Mrs. Frank E. Richardson, and The Vincent Astor Foundation Gifts, Wrightsman and Gwynne Andrews Funds, special funds, and Gift of the children of Mrs. Harry Payne Whitney, Gift of Mr. and Mrs. Joshua Logan, and other gifts and bequests, by exchange, 1995

Fig. 23 Giovanni di Ser Giovanni Guidi, Lo Scheggia (1406–1486)
The Adimari Panel (detail), about 1450
Egg tempera on wood, 88.5 × 303 cm
Galleria dell'Accademia, Florence

OPPOSITE
Detail of *The Triumph of David* (cat. 6)

In the absence of firm documentation, the proposition must remain conjecture. However, returning to the imagery itself, two further aspects may lead us once again to the Medici. Firstly, Pesellino's *Triumph* echoes celebrations which took place in Florence on the feast of the Epiphany, as described by contemporary chroniclers. One account of the procession of the Magi that took place in 1429, when Pesellino was a boy of seven, describes the figure of David being wheeled through the streets on a cart: 'And upon a cart the figure of David, who killed the giant with a sling. And the person acting David went fully erect and with great skill on the cart.'[42] By the 1450s, when Pesellino was painting his David cassoni, the Medici were in full control of the confraternity of the Magi, which was headquartered at the convent of San Marco, and the civic festivities for the feast of the Magi had reached an apex, being held every five years.[43] While there are no descriptions at these later events of David on his cart, this may well have remained a feature of the procession, which only grew in size and ambition under Medici aegis. The Magi procession – which always included a cavalcade of horses in their hundreds – had become an important means by which to flex Medici power and assert political dominance through the conduit of traditional patriotic display.

Finally, the last scene in the panels' narrative may be intended to evoke the women of the family in particular. As already indicated, the encounter at the right of the *Triumph*, between the splendidly dressed women and the men who lead the procession, has often been understood as a representation of a wedding (see detail on p. 3). Certainly, the women's finery recalls the type of garb traditionally found in cassone depictions of wedding ceremonies. But if this is a wedding (perhaps that of David and Michal, daughter of Saul) it is unclear which of the figures are the bride and groom. Traditionally the woman with the lavish peacock feather headdress has been identified as a bride,[44] the peacock being the symbol of Juno, ancient goddess of marriage and childbirth. Among the items of clothing that the Florentine merchant Marco Parenti gave his new bride, Caterina Strozzi, in 1449 was a headdress in the form of a 'garland of peacock feathers'.[45] A similar headdress appears in the so-called *Adimari Panel* (fig. 23) as well as in a later drawing by Maso Finiguerra in the Uffizi.[46] Returning to Pesellino's group of women, technical imaging has revealed that the lady in the dress that is now pink, probably once a deeper crimson, standing to the right of her peacock-feather adorned companion, originally wore a simpler, lower headdress. Pesellino adjusted it late in the painting process, transforming it into the so-called *sella* (a saddle-shaped headdress) that we see today. This is one of the very few changes that Pesellino made to his design that has been detected. The adjustment is intriguing, not least because the elaborate *sella* headdress had been banned by Florentine sumptuary laws in 1449 (a decree reiterated in the laws of 1456).[47] Certainly, only women of the highest status, those deemed effectively above the law, would have continued to sport the garment.

It is unlikely that Pesellino intended any of these women as portrayals of specific individuals. But perhaps, just as the soldiers' uniforms and their feathered helmets allude to the Medici in one way, these women denoted the Medici dynasty in another. Indeed, the two young girls are about the same age that Bianca and Nannina would have been when Pesellino was working on the chests. Could the three women who stand in a line in front of them have been conceived as an evocation of the triumvirate of Medici women who occupied the palace in those years, Contessina de' Bardi, Lucrezia Tornabuoni and Ginevra degli Alessandri? Certainly, they are clothed in the sartorial finery to which the Medici women were accustomed. That they may even have recognised some of the garments in Pesellino's portrayal is indicated by a comparison of the dress worn by the woman in the *sella* headdress with a description in the 1456 Medici inventory from a list of items of clothing belonging to Lucrezia Tornabuoni: 'a *cotta* [a type of gown] of crimson pile-on-pile velvet with sleeves of gold brocade'.[48]

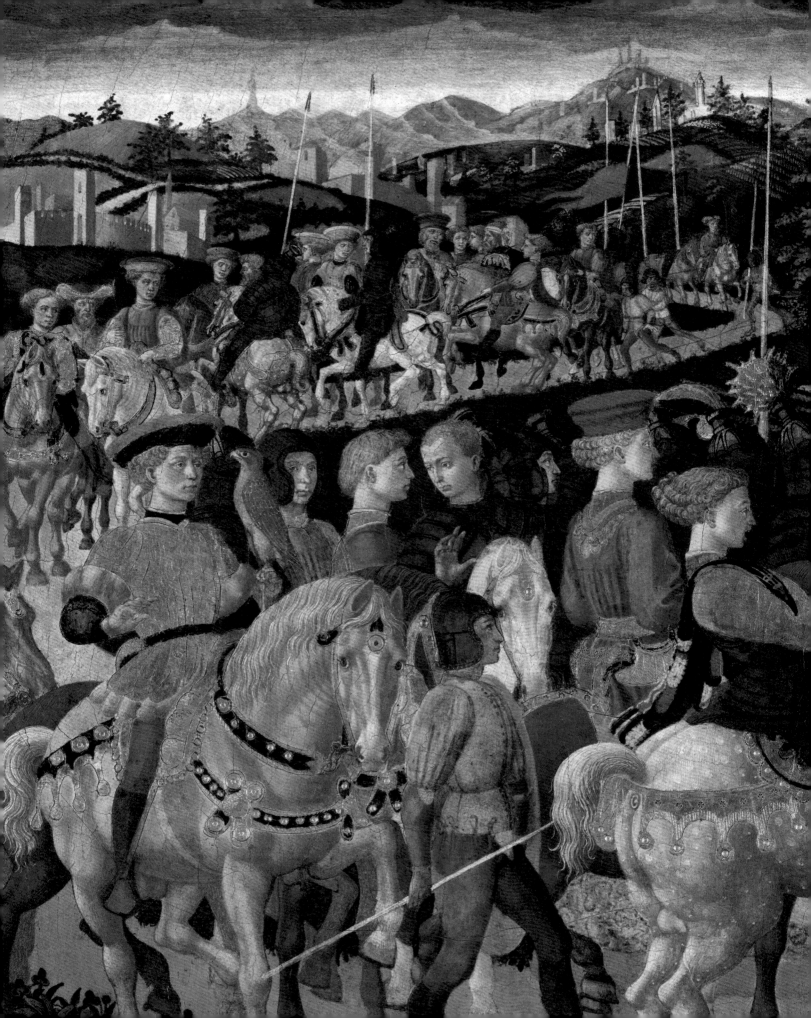

Cassoni or spalliere: an alternative viewpoint

NATHANIEL SILVER

THE original function of the David panels remains a matter of debate. If they originally adorned cassoni as proposed above, rather than being integrated into chests at a later date – which could also explain the recently identified key damage – then they were presumably accompanied by additional paintings by Pesellino in the form of *testate* (painted panels inserted at the short ends of the chests). The most recent reconstruction of *The Story of David and Goliath* and *The Triumph of David* as the fronts of two lost chests completes them with a pair of *testate*, also attributed to Pesellino, in Kansas City and Le Mans.[49] However, this hypothesis fails to account for stylistic differences between the London paintings and the *testate*, as well as the distinction between their subjects, David as a young man in the former and David as king in the latter.[50] Furthermore, comparison of his *Battle* and *Triumph* with a pair of Pesellino's Boston panels (see fig. 14) – securely identified as cassoni on the basis of technical evidence – reveals differences in style, technique and scale.

Unlike most cassone panels, Pesellino's David paintings are underpinned by labour-intensive and complex drawing. Infrared examination has revealed densely hatched modelling in the underdrawings, especially in the clothing of David (see fig. 41). The detailed preparation of the hero is matched by technically difficult drawing of the secondary figures, captured in complicated poses including radically foreshortened dead soldiers and others captured in mid-fall from their horses. The level of precision and difficulty embedded in his designs invites the viewer's admiration and careful scrutiny.

Dillian Gordon and Miklós Boskovits both raised the intriguing possibility that Pesellino's David panels may have formed a spalliera.[51] Both stories unfold in clear and visually convincing landscapes with consistent horizons. Groups of figures throughout the David panels are carefully integrated into the fore-, middle- and background landscape and diminish in scale into the distance, enhancing the impression of deep pictorial space and contributing to the illusion of naturalism. The lush painted landscapes invite contemplation of the fictive environment as an extension of the viewer's own world and suggest that, like a spalliera, the panels were originally visible at or nearer to eye level than a chest ever would have been.

Although the David panels share many defining features in common with spalliere as identified by Anne Barriault, they predate most documented or clearly identified examples (for discussion of the panels' date, see p. 20).[52] The panels do not appear in the Palazzo Medici inventory, nor can they be securely identified with a lost spalliera by Pesellino in another Medici residence (the *casa vecchia*). However, the description of that one ('a spalliera very beautifully [adorned] with animals') recalls both the David panels' spalliera-like qualities and conspicuous display of skill in animal painting (see pp. 19–21), the hallmark of Pesellino's artistic identity according to Vasari (see p. 30).

Pairs of spalliere were often twinned with cassoni. If the David paintings were conceived as a spalliera, then two chests probably accompanied them. One plausible set of cassoni attributed to Pesellino's workshop depicts an unidentified battle and subsequent triumph (fig. 24).[53] Like the young female attendant wearing a dress embroidered with a falcon in Pesellino's *Triumph*, the foot soldier at the far right of the *Battle* panel bears a shield with a similar bird, an emblem identified with Piero de' Medici.[54] These two paintings also seem to respond to the David panels' compositions. The orchestrated battlefield chaos recalls Pesellino's engagement of

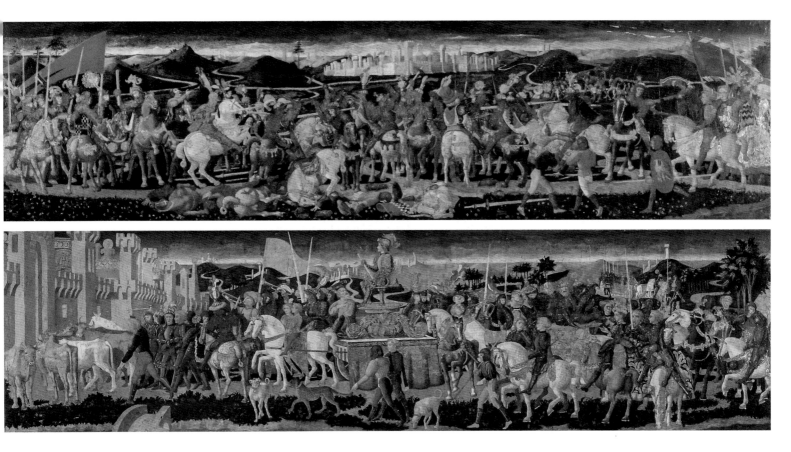

Israelites and Philistines, including minute combatants fighting in the background, even if the cassoni do not fully exploit the spatial potential of the landscape for narrative purposes. Similarly, the city wall and empty winding road suggest, but limit, the illusion of space that is a compelling part of the David paintings. Their schematic relationship to the David panels aligns with the depiction of staged combats and triumphs executed in a more common format. They evoke Vasari's description of Pesellino's cassoni in the old Medici house depicting 'little scenes of jousts on horseback', which could have been the pendant to the lost spalliera of animals mentioned earlier.

Several imitations of the David panels survive. All of them appear to post-date Pesellino and suggest that the National Gallery works were an important prototype. Indeed, they may have even initiated a taste for the story of David to be depicted in a more schematic form on cassone panels (see pp. 42–3).[55] The Medici were taste-makers of innovative domestic artwork, as in the case of Donatello's bronze statue of David, which also spawned reduced versions of varied quality for indoor locations. When considered in the context of Pesellino's career, his close family ties to the Medici and their taste for his animal paintings – in addition to the innovative nature of his David images and the imitations they spawned – then, as also argued above, the National Gallery's panels emerge as a likely commission by or for a Medici family member, possibly Piero di Cosimo who decorated the *piano nobile* apartment of Palazzo Medici.[56]

Fig. 24 Workshop of Pesellino
Battle Scene and *The Triumph of a Young Warrior*, about 1455
Egg tempera on wood, 45 × 157 cm each
Private collection

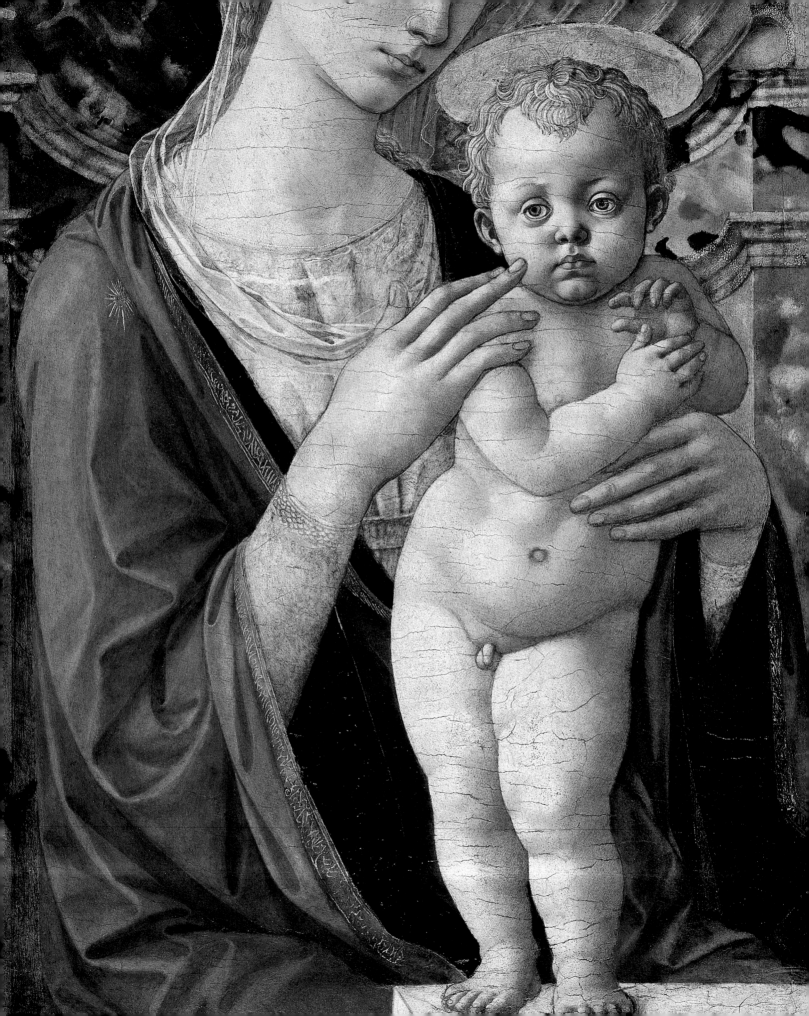

Pesellino's legacy

LAURA LLEWELLYN

FORGETTING PESELLINO

AMONG writers and chroniclers in Florence in the decades following Pesellino's death, there was an unravelling of the distinction between the artistic personalities of the painter and his grandfather. An apparent source of this confusion is that both artists produced artworks for the Medici residences, and both had notable abilities as painters of animals (see pp. 19–20). The architect Filarete singled out Pesellino for his animal paintings, while 15 years later Cristoforo Landino identified this as Pesello's great talent.[1] Later still, around the turn of the century, in the longer, more detailed accounts of Florentine works of art by Antonio Billi and the Anonimo Magliabechiano (Gaddiano), the confusion became more entrenched, with a number of Pesellino's works attributed to his grandfather.[2]

Vasari's account of the life of Pesellino, presented together with that of his grandfather (who Vasari believed to be his father), apparently relied in part on the Billi and Magliabechiano manuscripts and represents the final burnishing of the confusion between their work. Vasari also muddled things further, stating that Pesello was trained by Andrea del Castagno, for example. Nonetheless, there are two key things about Pesellino's career and art which he alighted on, and in so doing demonstrated his perceptiveness regarding Pesellino's achievements: first, his collaboration with Fra Filippo Lippi and the extent to which this interaction impacted his formation as a painter, and second, his noteworthy talent and precision as a draughtsman.

In closing, Vasari mused on how much more Pesellino might have achieved if he had only lived longer: 'From what we know of him, if he had lived longer, he would have achieved much more than he did, because he was a diligent student of his art and never stopped drawing day or night.'[3] This sentiment – which was echoed by Berenson when he described Pesellino as 'Florence's Giorgione' – and its implications are explored in the following pages.[4] Despite the growing confusion in the written sources, Pesellino's art subsisted in myriad ways and in various forms in the generation after his death. Even as his name began to fade from collective memory, his legacy is manifest in numerous developments in Florentine painting over subsequent decades.

COMPLETING PESELLINO

When Pesellino died suddenly in the summer of 1457, there must have been a number of projects and unfinished commissions which were either never completed or were taken over by others. The best known (and only documented) instance of the latter was the altarpiece for the confraternity of priests at Pistoia, left standing apparently 'half finished' in his workshop at his death and seen to completion over the next three years in Lippi's workshop (see cat. 8 and pp. 22–3). In death, Pesellino, whose career had been punctuated, even defined, by collaborative endeavour, entered unwittingly into his final collaboration. In this posthumous partnership he came full circle, his career

OPPOSITE
Detail of *Virgin and Child* (cat. 7)

bookended by collaboration with Lippi, for whose own altarpiece for the Novitiate Chapel in Santa Croce he had produced the predella (cat. 1 and fig. 2) more than fifteen years earlier. As a consequence, in this project, Pesellino was outlived by his art in very literal terms.

While the identification of the hand of Pesellino, Lippi or other unnamed painters in the altarpiece is the subject of unresolved debate, it is broadly agreed, not least on the basis of the underdrawing, visible to the naked eye, and infrared photographs, that Pesellino designed the entire composition of the main panel, *The Trinity with Saints*, before he died.[5] Given what we know about Pesellino as a draughtsman and meticulous designer (see cat. 6), it is entirely unsurprising that in this commission, his most ambitious to date, he would have worked hard to establish his design before taking up the paintbrush. When the confraternity was faced with the decision of who should see this design to completion, practical considerations probably played a role. Lippi's workshop was in Prato by this date, midway between Pesellino's in Florence and the Pistoiese church for which the altarpiece was destined. From here the confraternity would be well placed to oversee the altarpiece's completion at close quarters.[6] Moreover, Lippi's workshop at this time was the most prolific site of altarpiece production in the region. In consigning the altarpiece to the friar painter, the confraternity, possibly feeling cautious after the vicissitudes of the project to date, would perhaps have felt the task to be now in safe hands. But the choice has also rightly been interpreted as an indication that Pesellino's artistic manner was understood by his own contemporaries as belonging to the same idiom as that of the elder master, just as Vasari later observed.[7]

From the wealth of information that comes out of the altarpiece commission documents, the subsequent litigations over money owed and the eventual reassignment of the commission, we learn about a number of Pesellino's relationships with artists other than Lippi. On 10 July 1457, when Pesellino was deemed too unwell to continue with the commission, Domenico Veneziano, together with Lippi, was asked to provide an evaluation of the work, in particular its state of finish. As explored elsewhere (see cat. 8), it may be that they were both selected for this task because of their previous working relationship with the younger painter.[8] The other two individuals who emerge from the Pistoia documents as having been professionally associated with Pesellino are Piero di Lorenzo Pratese and Zanobi di Migliore, two specialists in painting banners and furniture respectively, with whom he formed a profit-sharing partnership in 1453 (see p. 21).[9] Although the latter withdrew from the coalition shortly thereafter, Piero di Lorenzo and Pesellino remained associates, to the extent that, in the wake of Pesellino's death, Piero went before the tribunal of the Mercanzia in a dispute with Pesellino's widow over what he declared was owed to him of the fee paid to Pesellino before his death for the Pistoia Altarpiece.[10]

REPLICATING PESELLINO

While difficult to prove definitively, it may be that Piero di Lorenzo can be identified with the other artist, besides Lippi, responsible for perpetuating designs by Pesellino after his death. *The Trinity with Saints* was in fact just one of Pesellino's autograph designs that was painted by other hands in subsequent decades. His most widely and repeatedly copied designs were those for painted images of the half-length Virgin and Child. This relatively new type of domestic image had been pioneered by Florentine artists of the generation before Pesellino, when the Virgin and Christ Child replaced the Crucifix as a requisite devotional feature in the Florentine household and as ownership of such works became standard among the burgeoning middle classes of the city.[11] Artists' workshops (*botteghe*), of both sculptors and painters, quickly responded to the surge in demand

OPPOSITE

Fig. 25 *Virgin and Child with Saint John and Angels*, about 1455
Egg tempera on wood, 72.4 × 54 cm
Toledo Museum of Art, OH
Purchased with funds from the Libbey Endowment, Gift of Edward Drummond Libbey, 1944.34

Fig. 26 *Virgin and Child with a Swallow*, about 1453–7
Egg tempera on wood, 59.7 × 39.5 cm
Isabella Stewart Gardner Museum, Boston

Fig. 27 *Virgin and Child*, 1450s
Egg tempera on wood, 60 × 36.6 cm
Christian Museum, Esztergom

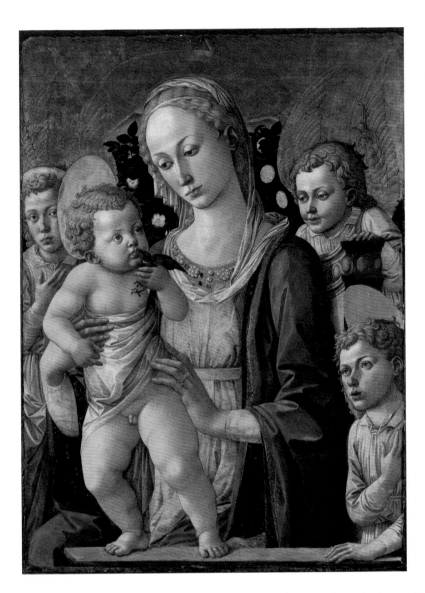

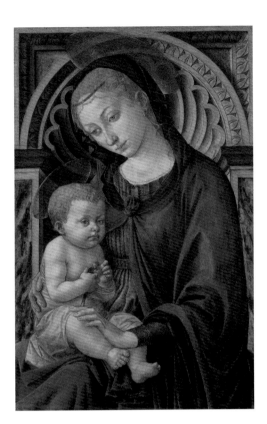

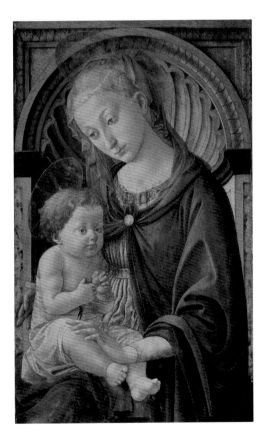

for such works and by the second half of the century, for many *botteghe* the production of this type of image had become their bread and butter.[12] Indeed, it is generally agreed that some workshops – or 'factories' as Martin Davies referred to them[13] – were set up exclusively to produce these kinds of painted works for the 'mass' market.

Three *Virgin and Child* types, apparently painted as well as designed by Pesellino, survive. One is found in Toledo, Ohio (fig. 25), another in Lyon (cat. 7) and a third exists in two versions, today in Boston (fig. 26) and Esztergom (fig. 27). These three types were subsequently widely replicated, from almost precise copies to more loosely conceived replicas, sometimes including additional figures. The copies range greatly in painterly quality and the painter(s) who made them, formerly identified as the Pseudo-Pier Francesco Fiorentino,[14] are today known as the Lippi Pesellino imitator(s).[15] The works themselves demonstrate varying degrees of sophistication and fidelity to their respective prototypes. Compare, for example, the Washington version (fig. 28) of the Lyon prototype (cat. 7) with its sensitive response to the treatment of light and shading in the original and the incorporation of the striking motif of the rose bush backdrop, to the version in the Victoria and Albert Museum (fig. 29) with its comparatively wooden treatment of the figures, schematic tooled gold background, two-dimensional haloes,

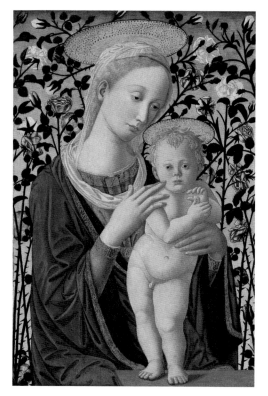
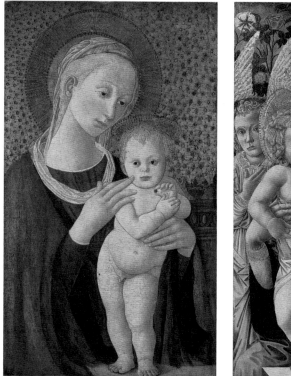
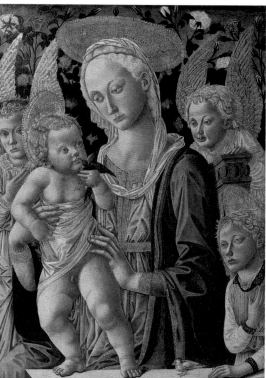

Fig. 28 Lippi Pesellino imitator (active 1450–1500)
Virgin and Child
Egg tempera on wood, 67.2 × 46 cm
National Gallery of Art, Washington
Widener Collection

Fig. 29 Lippi Pesellino imitator (active 1450–1500)
Virgin and Child
Egg tempera on wood, 67 × 40.5 cm
Victoria and Albert Museum, London

Fig. 30 Lippi Pesellino imitator (active 1450–1500)
Virgin and Child with Saint John and Angels, 1459
Egg tempera on wood, 81 × 62 cm
Gallerie degli Uffizi, Florence

blank facial expressions and lack of modelling in the features. Even allowing for varying states of conservation, the differences apparently indicate the relative distance between the copyist in each instance from the original painting.

The sheer quantity of surviving works made after Pesellino's designs indicates a formal system of production.[16] It may be that the original partnership was formed precisely because the three men had identified gaps in the market for domestic painting. Seeing that bulk production of painted Virgin and Child half-lengths represented a lucrative business opportunity, they perhaps put a formal partnership in place to streamline the production process and meet demand. Pesellino's two autograph versions of the same design in Boston (fig. 26) and Esztergom (fig. 27), which have just a few variations in the treatment of the hands and Virgin's veil, provide evidence of the master himself experimenting with methods for creating replicas and so point to the likelihood that the practice of imitation was initiated in Pesellino's workshop.[17]

A painting in the Uffizi, the only dated work by the Lippi Pesellino imitator(s) (1459, fig. 30), is a close copy of Pesellino's Toledo *Virgin*. It is a work of relatively high painterly quality, and the pronounced transitions from light to dark in the skin tones seems to be the result of direct study of Pesellino's original. In fact, the treatment of light over the features, resulting in ruddy complexions and strong white highlights, finds direct comparison with a painting in Philadelphia (fig. 31),[18] which reproduces the Lyon composition, as well as a panel (fig. 32) which is after the Esztergom/Boston design. Shared stylistic characteristics of these works seem to indicate a single hand, perhaps that of Piero di Lorenzo himself.[19]

Given what we know of Pesellino and Piero di Lorenzo's lasting business arrangements, it is plausible that initially the copies were made by Piero himself and then, as the enterprise grew, by other artists under his direction.[20] The workshop on corso degli Adimari, formerly belonging to Pesello, was sold to Piero di Lorenzo in

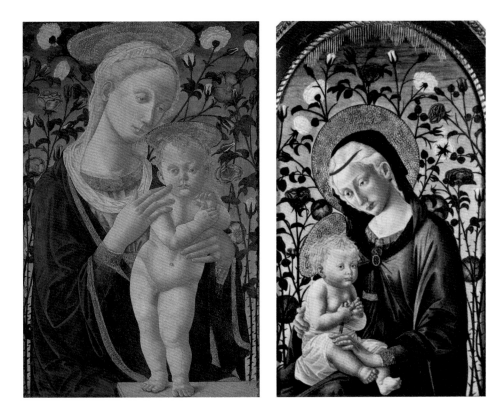

Fig. 31 Lippi Pesellino imitator
(active 1450–1500)
Virgin and Child
Egg tempera on wood, 74.6 × 52.1 cm
Philadelphia Museum of Art
John G. Johnson Collection, 1917

Fig. 32 Lippi Pesellino imitator
(active 1450–1500)
Virgin and Child
Egg tempera on wood, 72.5 × 43 cm
Private collection

1453 and remained active until 1486. A workshop that was operating for over thirty years, which is likely to have had some turnover of painters working within it, would certainly explain why the initial homogeneity and relative quality of the earliest copies, those perhaps made by Piero under Pesellino's aegis, gave way to derivations with greater variations in painterly quality after a few decades.

Piero di Lorenzo never seems to have been considered for the completion of the Pistoia Altarpiece, a further indication that he specialised in the more artisanal activity of producing repetitions of Madonnas from Pesellino's cartoons. The plausibility of the identification of the original Lippi Pesellino imitator as Piero di Lorenzo is also bolstered by the fact that the painter in question appears to have begun their activity relying on designs by Pesellino, but later also gained access to designs by Lippi. In addition to producing copies of small-scale domestic devotional works by both masters (see figs 11, 15), the workshop also produced replicas of a number of Lippi's altarpieces, in particular those where the originals belonged to the Medici. What seems clear is that the designs required to produce such copies were being used with express permission. In this respect, the Lippi Pesellino imitator workshop was different from that of Neri di Bicci, for example, who often took inspiration from the paintings of his contemporaries, such as Lippi or Fra Angelico. The Pesellino Lippi imitators were not making paintings *inspired* by these painters, but evidently had access to cartoons and drawings that enabled them to make precise replicas at a rate that was unapologetically prolific. It is entirely feasible that, in the wake of Pesellino's death, Lippi and Piero came into contact as they both played a role in disbanding Pesellino's workshop, perhaps sharing the drawings of their deceased friend and colleague between them. It is possible that in this period, they reached an agreement that Piero would continue to make replica paintings, with an expanded repertoire to include designs by Lippi, and the friar painter now had the opportunity to partake of the profits.

PERPETUATING PESELLINO

In addition to paintings made specifically to Pesellino's designs, his work also informed painters in the decades after his death in looser but nonetheless meaningful and lasting ways. For example, it is striking to observe how Pesellino's David cassoni pervaded the approach of subsequent cassone painters. Lo Scheggia's cassone panels painted on the occasion of a union between the Carnesecchi and Lanfredi families (fig. 33), probably late in his career (about 1467),[21] reflect his study of Pesellino's earlier version (cat. 6), with many elements reprised.[22] Lo Scheggia borrowed Pesellino's placement of the dramatic encounter between David and Goliath at the centre of the action, taking place across some distance (a compositional device Pesellino had in turn adapted from Ghiberti). David is captured mid-swing with sling thrown back and the later moment, when he decapitates the giant's felled body as it lurches into the foreground, appears in the space between them. Perhaps even more significant in terms of Pesellino's legacy, beyond individual elements of repetition and inspiration, is Lo Scheggia's ambitious implementation of a receding landscape and the consequent richness of the narrative tableau. In the accompanying *Triumph*, Lo Scheggia once again echoed Pesellino's earlier conceit, the jubilant procession moving across the foreground with Saul and David borne aloft on triumphal carriages, though the direction is reversed and the cavalcade moves from right to left. Lo Scheggia's *Triumph* was inserted into the body of a new cassone in the nineteenth century, together with two *testate* which depict heroic adventures of Hercules after compositions by the Pollaiuolo brothers, at least one of which was originally made for the Medici.[23] It may be that these *testate* did not originally form part of the same cassone as the David frontal.[24] Nonetheless they provide additional evidence of cassone painters in the later part of the century drawing on major works of art in lavishly decorated patrician dwellings, especially Palazzo Medici, suggesting that the market for pieces imitating those made for the city's leading family was buoyant.

Beyond specific representations of the story of David, Pesellino's paintings seem to have helped establish a trend for cassoni imagery in Florence in the second half of the fifteenth century, notably the pairing of a battle with a triumph (see p. 31).[25] Another pair of cassoni panels in a private collection (fig. 24), which have been associated with the workshop of Pesellino, reprise a number of the most successful and engaging elements of Pesellino's David panels. In this later cassone pair, the *Triumph* in particular reveals a significant reliance on the David *Triumph*, such as in the position of the prisoners (back-to-back with hands bound), the processing cheetah, the white dog near the front (paw raised and chin lifted in daring foreshortening) and the trumpeters with puffed cheeks at the front of the procession. Moreover, the drinking horse towards the back of the procession is lifted from Pesellino's *Battle* panel, and the cow at the far left is taken from the scene showing David with his flocks. The repeated inclusion of specific individual elements copied from Pesellino's earlier panels seems to refute the proposal that the later, possible workshop panels may have been intended to be displayed as an ensemble with Pesellino's David panels (see p. 34). These two pairs of later, derivative cassoni, both in private collections (figs 24 and 33), encapsulate how Pesellino's David panels informed later cassone painters in two broad ways. In the case of Lo Scheggia, there is a reliance on the example of Pesellino's dramatic narrative and compositional ambition, while the panels perhaps made in Pesellino's workshop are an instance of Pesellino's works being mined for all their intricate details, perhaps by a painter with access to the master's drawings.

The National Gallery's *Stories of David* have not entered the discourse as squarely as perhaps they should have done in the discussion of the development of Davidian iconography in fifteenth-century Florence. Ghiberti's example on the east doors of the Baptistry has been inevitably – and justifiably – cited as a major source of inspiration for Pesellino in conceiving his scenes (see p. 20). Pesellino followed Ghiberti's example

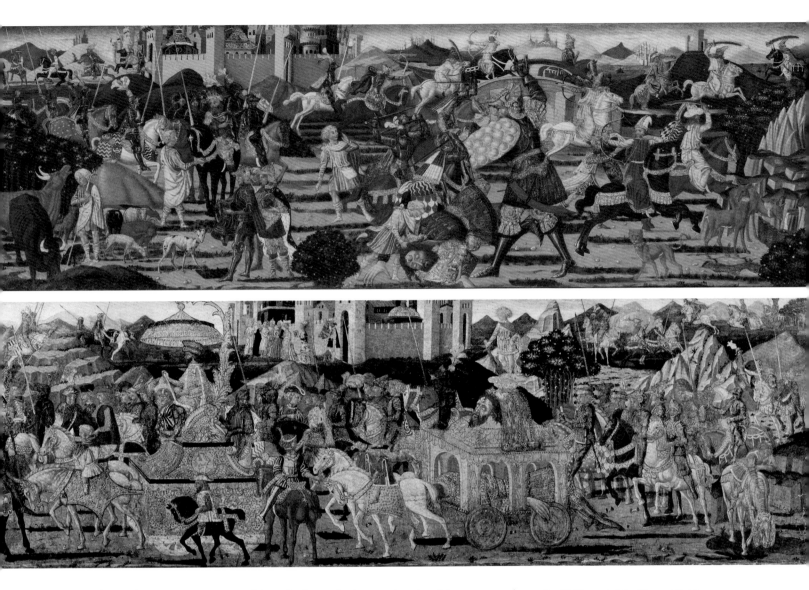

in placing the gruesome moment of decapitation at the front and centre of the scene, and in modelling the poses of each figure, Goliath sprawled face down, David with bent knees in profile. However, much of his imagery is without firm precedent and became standard-setting for the nascent iconography of the young David that was codified by Florentine artists of the subsequent generation.[26] The swagger of Verrocchio's bronze and the vigour of the Pollaiuolo brothers' painted shield both seem reliant on Pesellino's precedent.[27]

Even though Pesellino's ambitions as a painter of altarpieces were cut short, those that he produced also seem to have become a locus of artistic study, and even continued to attract the interest of artists into the following century. Intriguingly, several drawings survive, which show artists copying Pesellino's figural designs. A large red chalk drawing in the Uffizi (fig. 34), apparently dating to the first decades of the sixteenth century, copies one of the condemned saints in *The Martyrdom of Cosmas and Damian* from the Novitiate predella. Perhaps slightly earlier, a pair of large pen, ink and wash drawings (figs 35, 36) shows individual figures of Saints Mamas and Jerome from the Pistoia Altarpiece, the exaggeratedly large eyes in both apparently indicating the same hand.[28] Additionally, two copies of the heads of saints in the Louvre altarpiece (fig. 13), drawn on a single sheet in black chalk or charcoal (figs 37, 38) appear to be more hastily sketched, later responses to this work, though they are believed by some to be by Pesellino himself (see p. 22).[29]

Fig. 33 Giovanni di Ser Giovanni Guidi, Lo Scheggia (1406–1486)
The Slaying of Goliath and *The Triumph of David*, about 1467
Egg tempera on wood, 41.6 × 132.3 cm and 39.7 × 130.2 cm
Private collections

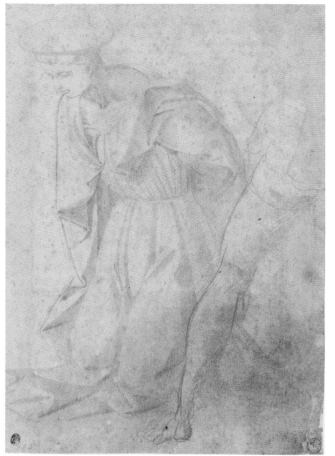

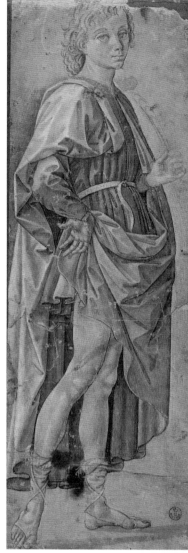

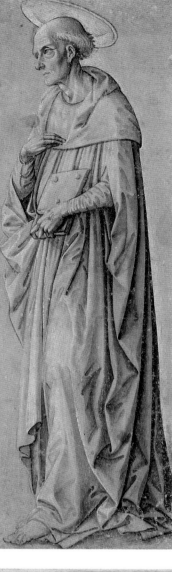

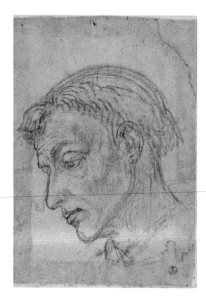

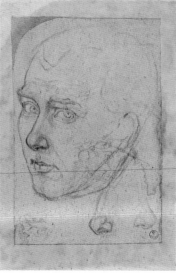

CLOCKWISE FROM TOP LEFT

Fig. 34 After Pesellino
Study of a Detail from The Martyrdom of Cosmas and Damian, early sixteenth century
Red chalk on paper, 25.8 × 19.1 cm
Gabinetto dei Disegni e delle Stampe,
Gallerie degli Uffizi, Florence, inv. 689S

Fig. 35 After Pesellino
Saint Mamas, 1470s (?)
Pen and ink with white heightening on
brown prepared paper, 35.2 × 12 cm
Gabinetto dei Disegni e delle Stampe,
Gallerie degli Uffizi, Florence, inv. 379E

Fig. 36 After Pesellino
Saint Jerome, 1470s (?)
Pen and ink with white heightening on
brown prepared paper, 36.8 × 12.5 cm
Städelsches Kunstinstitut, Frankfurt, inv. 5585

Figs 37, 38 Pesellino (?) or early sixteenth-century
follower of Pesellino
Study for the Head of a Saint, Noses (verso),
The Head of a Friar Saint (recto)
Black chalk on paper, mounted, 24.8 × 17.5 cm
Gabinetto dei Disegni e delle Stampe,
Gallerie degli Uffizi, Florence, inv. 16082F

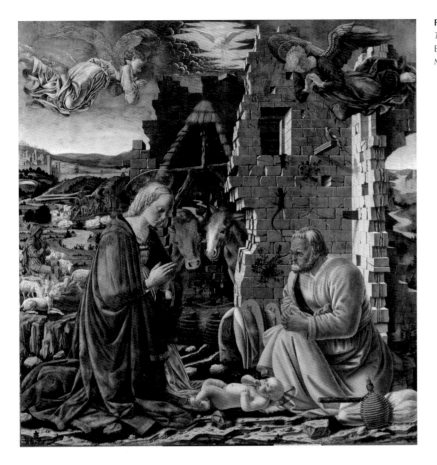

Fig. 39 Fra Diamante (1430–after 1498)
The Nativity, about 1460–70
Egg tempera on wood, 166.5 × 166.5 cm
Musée du Louvre, Paris

Pesellino's *The Trinity with Saints* also made a discernible mark on painters of altarpieces in the immediate decades after it was erected in the chapel in Pistoia. It has been observed that, when taking over the commission, the Lippi workshop probably came into possession of numerous Pesellino drawings. This would certainly explain the presence of Pesellino's figures, apparently made with the aid of cartoons, in the altarpieces produced by artists in Lippi's workshop, in particular those of Fra Diamante, such as the hovering angels in his altarpiece of the Nativity in the Louvre (fig. 39).[30] Another way in which we see Pesellino's composition reverberating into the next generation is in the work of the Pollaiuolo brothers. Their hallmark receding landscapes, with a body of water stretching to the far distance, typically and rightly discussed in terms of their interest in Flemish painting, must also be understood as developments of Pesellino's remarkable innovation in the Pistoia Altarpiece (see p. 66).

Francesco del Pugliese's selection of Pesellino to form part of his proto-gallery in the chapel of his villa at Sommaia (see pp. 18–19, n. 17) bespeaks Pesellino's posthumous reputation among the most discerning patrons of art in Florence, even at a distance of some decades from his death. And even as his name and personal identity were beginning to slip and coalesce with that of his grandfather, Pesellino's art continued to stimulate and engage artistic production. This engagement, as we have seen, took myriad forms – from mechanical reproductions of designs furnished for the specific purpose of replication, to groundbreaking works which drew upon Pesellino's ambitious compositional, figural, typological and narrative innovations. The reverberation of Pesellino's art in the work of generations of artists that came after him serves as a reminder that to overlook him is to overlook a key chapter in the story of Florentine painting, and the associated questions of the developing discourse on artistic style and taste.

CATALOGUE

1

FRANCESCO PESELLINO (1422–1457)

The Stigmatisation of Saint Francis and *The Miracle of the Black Leg,* about 1442–5

Egg tempera on wood, 32 × 94 cm (panel with two painted scenes)
Paris, Musée du Louvre, Department of Paintings, INV 418

THE predella of Fra Filippo Lippi's altarpiece for the novice's chapel in the convent of Santa Croce, Florence (see fig. 2), was attributed to Pesellino as early as 1510.[1] The construction and embellishment of the Novitiate Chapel (about 1439–45) was funded by the city's *Pater Patriae* Cosimo de' Medici, to whose patron saints, Cosmas and Damian, it was dedicated.[2] Part of a wider architectural complex for the exclusive use of novice friars, the chapel was located at the entrance to the dormitory.[3] Although the commission is not documented, it is likely that Lippi was hired to paint the altarpiece in the first half of the 1440s.[4]

Emerging from his grandfather's workshop, Pesellino was probably about twenty when he received the commission for the predella. We do not know precisely how he came to collaborate with Lippi, but the move is not surprising. It was common for early-career painters to hone their skills and develop their experience with stints in other workshops. It is possible too that Pesellino came on board on the recommendation of Cosimo himself, given his grandfather's long-standing association with the Medici (see p. 9).

Pesellino's predella consisted of five octagonal scenes painted along a single panel. Each scene depicted an episode from the life of the saint who appeared directly above in the main panel. The predella was sawn in two, perhaps in the early nineteenth century, and this section, the leftmost part, entered the collection of the Louvre.[5] It shows two scenes from the lives of Saint Francis and Saint Damian (together with his brother, Cosmas). In the first the rough wilderness of La Verna, where Francis miraculously received the stigmata, is represented as a barren outcrop set between two soaring masses of rock.

Their rippling, stalagmite-like forms, accentuated by strong light from the left, as well as the spiked clouds and carefully described folds of both friars' habits, evoke the stylised forms, pure colours and bold light of manuscript illumination. Though Vasari later observed that Pesellino's 'marvellous predella' could almost be mistaken for a work 'by the hand of Fra Filippo',[6] recent commentators have observed their more evident proximity to the works of Fra Angelico in the 1440s, with forms made up of blocks of strong colours and sharp shadows. Pesellino's abilities as a miniaturist soon found full expression in his collaboration with Zanobi Strozzi on the *De Secundo Bello Punico* manuscript, a probable commission from, or gift for, Pope Nicholas V (see figs 4–6 and p. 13).

The neighbouring scene – one of intimate domesticity and tender human interaction, whose warm palette is characterised by red tones – is a foil for both the drama and the inhospitable wilderness of the *Stigmatisation*. It depicts the episode when Saints Cosmas and Damian, both surgeons, miraculously cured a man's cancerous leg. In fifth-century Rome, a member of the Church of Cosmas and Damian dreamt he was visited by the two saints, who amputated his rotten leg and replaced it with the leg of a recently deceased Ethiopian man, whose body was interred in the nearby cemetery. Upon waking, he found that his leg was miraculously cured and when his companions visited the tomb, they found the cancerous leg sutured to the dead man. While the most famous account of the miracle, that of Jacopo da Voragine's *Golden Legend*, makes no mention of skin colour, Pesellino followed Florentine precedent in showing the transplanted leg as black-skinned to give clarity to the visual narrative.[7] *LL*

PROVENANCE: Novitiate Chapel, Santa Croce, Florence, until 1813; removed and brought to the Louvre by 1814.

SELECTED LITERATURE: Miller 1983, pp. 180–97; Ruda 1993, cat. 32, pp. 414–16; Holmes 1999, pp. 191–213; Thiébaut 2007, p. 45; Silver 2012, pp. 124–43.

2

FRANCESCO PESELLINO (1422–1457) and collaborator
King Melchior sailing to the Holy Land, about 1445–50

Egg tempera and oil (?) on wood, 65.1 × 69.8 cm
Clark Art Institute, Williamstown, Massachusetts, USA, inv. 1955.940

THIS is one of two panels from what was presumably a series of at least three scenes depicting the journey of the Magi. The other surviving panel, today in Strasbourg, depicts the journey of Caspar and is attributed to Zanobi Strozzi.[1] According to the Gospel of Matthew (2:1–18), wise men journeyed from the East to pay homage to the newborn Christ Child. Although Matthew does not recount how many there were, their gifts of gold, frankincense and myrrh contributed to the development of a tradition of three individuals: Caspar, Melchior and Balthazar.[2]

Here, Melchior, the eldest, sits on a raised throne at the stern of a ship with billowing sails, accompanied by smaller vessels. Wearing a large crown, both the cloth against which he sits and his garments are woven with gold. On his knee is a casket containing the gold he will present to Jesus. Brightly attired travellers cross an impossibly short stretch of water between two lands, with stylised mountains and miniature walled cities. Their departure is watched from the shore by a lavishly dressed hunting party with a dog and falcon. The fantastical scene is punctuated by incidences of naturalism: the foamy spray where the boats cut through the water, the fastenings of the ship's rigging and the meticulous attention to the fall of light. In the distant skies, Pesellino has carefully recorded the way the undersides of clouds appear pink at sunrise.

Of all the works in the exhibition, this one's attribution has proved the thorniest.[3] The difficulties stem from the fact that this panel was another of the many collaborative projects Pesellino undertook. Certain faces, the treatment of drapery and hair and the spiked, holly-leaf clouds, all closely echoing the *De Secundo Bello Punico* miniatures (see figs 4–6), act in support of attribution to Pesellino. However, aspects of the work, some facial types in particular, indicate the presence of another hand.

The three figures seated at the rear of the small vessel behind Melchior's ship represent two distinct types. The man shown in profile with a wide-brimmed hat has features (an aquiline nose and wide-set, almond-shaped eyes) in marked contrast to those of his companions, with pinched eyes, sunken eye sockets, straight noses and pointed chins. Likewise, the facial differences between two figures in Melchior's ship, both

grey and bearded, facing out near Melchior, encapsulate the two approaches. Apparently, either because Pesellino abandoned the project before completion or to ensure homogeneity between the panels, Zanobi Strozzi, or someone working closely with him such as Domenico di Michelino, executed a number of heads on Pesellino's panel.[4] This panel is one of several in Pesellino's oeuvre which show him collaborating even on small-scale works (see p. 19 and fig. 11).

The shape and size of the Clark and the Strasbourg panels make them difficult to categorise; they do not conform to the format of any standard altarpiece type or painted furnishing. There are two reasons to propose that the paintings were originally in Florence: our panel is first recorded in the Florentine collection of Alfonso Tacoli Canacci (1724–1801), whose collection was mainly sourced from Florentine churches and suppressed religious institutions,[5] and the subject reflects a distinctly Florentine interest in the cult of the Magi, revered and championed by the Medici (see p. 32). Perhaps they were intended to decorate the headquarters of the Confraternity of the Magi at San Marco.[6] Their commission by a member of the Medici family (or an institution closely associated with them) seems very probable.[7] Certainly, they are extraordinary works which present a crucial and little discussed precedent for the splendour of Benozzo Gozzoli's *Procession of the Magi* frescoes in the Medici chapel. *LL*

PROVENANCE: in the collection of Alfonso Tacoli Canacci, Florence, by 1791 and still in 1798; William Coningham, London; sold at Christie's, London, 9 June 1849, lot 20; Henry Labouchere, Lord Taunton, Stoke Park (Buckinghamshire) and Quantock Lodge (Somerset); by descent to his daughter Mary Dorothy Labouchere, the Hon. Mrs Edward Stanley; sold by her son Edward Arthur Vestey Stanley to Colnaghi and Obach; purchased by Robert Sterling Clark on 23 March 1914; in the collection of Sterling and Francine Clark Art Institute since 1955.

SELECTED LITERATURE: Berenson 1963, vol. 1, p. 61, pl. 633; Fahy in Milan 2001, cat. 12, pp. 71–5; De Marchi in Bentini, Cammarota and Scaglitti Kelescian 2004, pp. 220–3, n. 83; Kanter in New York 2005b, cats 54A and B, pp. 278–83; Strehlke in ibid., pp. 206, 213, n. 42; di Lorenzo in Prato 2013–14, cat. 3.3, pp. 136–9.

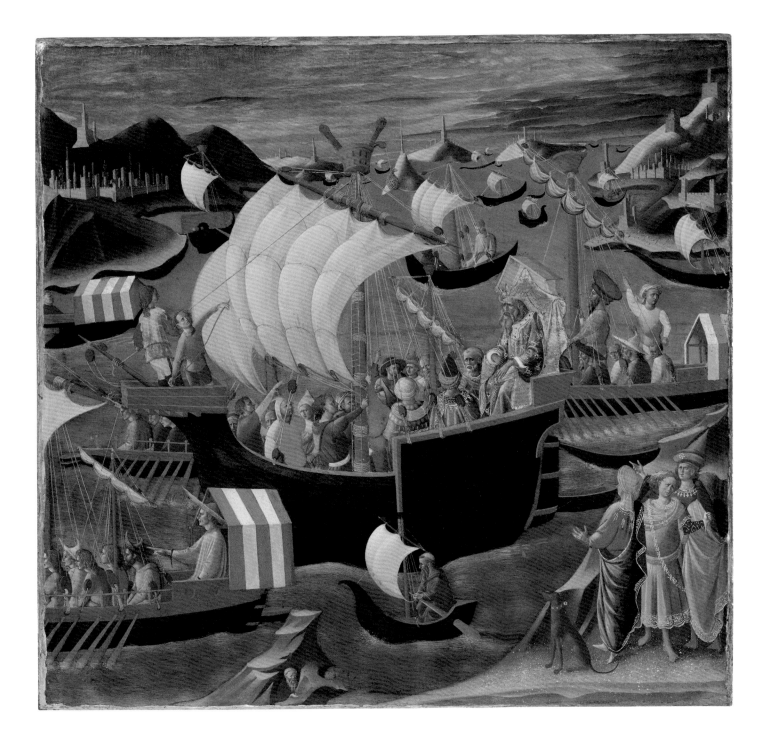

3

FRANCESCO PESELLINO (1422–1457)

Figure of a Bishop holding a Staff and a Book: Saint Augustine, about 1445–50

Brown gouache, heightened with white, on beige paper, 12.9 × 7.9 cm
Paris, Musée du Louvre, Department of Graphic Arts, INV 9856

THIS figure is directly related to the saint standing to the Virgin's proper left, typically identified as Augustine,[1] in Pesellino's exquisitely refined devotional panel today in the Metropolitan Museum of Art, New York (see fig. 7 and pp. 13–17). The little-known drawing has received scant attention and only from specialists concerned with establishing its precise relationship to the painted panel. There has been no consensus as to whether it was made as a preparatory study for the final painted figure or as a copy after it.[2] While a drawing such as this may always evade firm categorisation, some observations can help in establishing firmer ground. Firstly, the right side of the drawing shows, deliberately, the negative space occupied in the painting by the young warrior saint. The bishop's left sleeve is obscured by the area reserved for his companion's hand and, lower down, his robe is cut into by the angled edge of the youth's *pteruges* (pleated armoured skirt). Secondly, this fidelity to the figure's relationship to the wider composition is not matched in the treatment of the clothing. The mitre is a little squatter and exhibits none of the bejewelled splendour of the painted version, nor is the detailing in the robes reflected in the drawing. The thick gold border of his mantel, for example, is not indicated.

The outline of the figure left in reserve at right has been interpreted as evidence that this drawing was made after the painting.[3] However, it could equally indicate that the drawing represents one of many careful preparatory steps. If so, it provides a window onto Pesellino's meticulous design process. The negative space confirms that the placement of the figures on the panel was fixed at the point of making. The drawing does not bear any signs of transfer, such as pricking or incisions, so it is unlikely it was intended for this function.

It is however, as far as can be ascertained, on a one to one scale with the figure in the Metropolitan panel, possibly indicating it was made using the same cartoon.[4] Perhaps, once the compositional, spatial and individual figure studies were complete, Pesellino turned to making studies of light and modelling. His choice of medium – body colour and white heightening – is certainly well suited to a painterly exploration of the fall of light, as opposed to the quicker, more graphic pen and ink or charcoal media he preferred for preparatory figure sketches and cartoons for transfer (see fig. 51). Although the mitre is devoid of pearls, the drawing includes a single pearl on the left sleeve, a detail which in the finished painting Pesellino picked out from its shaded surroundings with a glistening white highlight. Such attention to light, in particular the fall of light over the body (compared with the lack of detailing in the mitre and the missing upper section of the crozier), points to the drawing having this specific function.

The drawing's characteristics may also be the result of Pesellino's commercially minded collaboration with other painters, who made replicas of his designs. The possibility of future reuse or replication may have driven the need to isolate this figure from the context in which it had been conceived, enabling insertion into a later composition. Whether made as a study of light late in the design process, or immediately after the painting was completed, perhaps to preserve the invention, the drawing is testament to the centrality of *disegno* in Pesellino's practice, providing evidence that even for panels on an exceptionally small scale, he made drawings of a quantity and range that we might more readily associate with the production of an altarpiece. *LL*

PROVENANCE: in the collection of the Marquis de Lagoy (Lugt 1710), from whom acquired by the Louvre in 1851.

SELECTED LITERATURE: Mackowsky 1898–9, pp. 83–4; Weisbach 1901, pp. 68–9; Berenson 1903, vol. 2, p. 129, under no. 1847; Meder 1919, pp. 664–5; Berenson 1938, vol. 2, p. 255, under no. 1841A; Paris 1952, no. 40B; Degenhart and Schmitt 1968, pp. 528, 539, fig. 769; Zeri 1971, p. 96; Kanter in New York 2005b, p. 288.

4

FRANCESCO PESELLINO (1422–1457)
The Annunciation, about 1450–3

Egg tempera on wood, 18.9 × 13.5 cm (left-hand panel); 19 × 13.1 cm (right-hand panel)
The Courtauld, London (Samuel Courtauld Trust), P.1966.GP.313

EXCEPTIONALLY refined and sophisticated, this portable work for personal devotion encapsulates the observation of Pesellino's contemporaries that he excelled 'in compositions of small things'.[1] Like the *Virgin and Child Enthroned with Six Saints* in New York (see fig. 7), it is a consummate example of his skill in rendering the monumental in miniature. In both scale and design, it is an image of captivating intimacy, characterised by exquisite attention to detail in the Virgin's domestic surroundings, gentle transitions between light and shadow and the tenderly reciprocated gestures of the two protagonists.

The subject of the Annunciation was especially important to Florentine patrons, not least because of the city's most famous miracle-working fresco at the Basilica of the Santissima Annunziata.[2] Fra Angelico and Fra Filippo Lippi, two painters whose examples loomed large in Pesellino's artistic formation, were the most innovative and prolific painters of single-field Annunciation altarpieces in the three decades that preceded this work. Pesellino adapted various elements from these earlier works: the elegant colonnaded loggia, the inner and outer sanctums of the Virgin's residence, the verdant *hortus conclusus* (enclosed garden). The mirrored poses of the two figures are relatively rare: more typically the angel kneels, while the Virgin sits or stands, or the angel stands before the kneeling Virgin. A precedent for the kneeling pair is a much earlier lunette painting by Lippi today in Washington DC (National Gallery of Art), where the figures occupy a single interior divided by a column.[3] Pesellino adopted the diffused light and soft shadows also characteristic of Lippi's work, moving away from his earlier preference for dramatically sun-drenched scenes

(see cats 1, 2).[4] He retained the column, but positioned Gabriel outside in the garden loggia, while the Virgin apparently occupies an elegant interior.[5]

These two panels were probably originally a single piece of wood. Whether they were sawn apart at the time of making or later in their history is difficult to resolve definitively.[6] Two holes on the inner edge of each panel, probably from hinges, and one hole at the upper outer edge of each, perhaps the remnants of a locking mechanism, certainly suggest that they were once hinged together and closable. The remnants of glue down the inner edges also show that, at one point, the two panels were fixed together and, presumably, displayed as a single object.[7] On balance, the material evidence acts in favour of the argument that the work was conceived as a diptych. First, the remains of a *barbe* (raised gesso edge) along both of the borders where the panels meet indicates that the two scenes were always divided by an engaged framing element and never shared a single field. Second, the heraldry on the versos, which has been identified as that of the Florentine Gherardi family,[8] is typical of decoration for diptych exteriors. Moreover, the verso surfaces are faded and damaged, when compared with the excellent condition of the rectos, damage consistent with a foldable object. The versos appear to have been painted using a distemper (glue-size) medium, rather than egg tempera, and they have no ground layer. These differences in technique between front and back have led to the suggestion that the backs were painted at a later date.[9] However, the difference in approach may perhaps be understood as a vestige of Pesellino's training with his grandfather, who specialised in the production of heraldic images. *LL*

PROVENANCE: W.B. Spence, Florence; sold Christie's, London, 9 April 1859, to Thomas Gambier-Parry; by descent to Sir Hubert Parry from 1888, Ernest Gambier-Parry from 1918, Mark Gambier from 1936; entered the collection of the Courtauld Institute of Art in 1966.

SELECTED LITERATURE: Courtauld Institute of Art 1967, p. 46; Angelini in Bellosi 1990, pp. 125–7; Ruda 1993, pp. 398, 490; Christiansen in New York 2005a, cat. 21, pp. 188–9; Cooper 2006; Silver 2012, pp. 185–94.

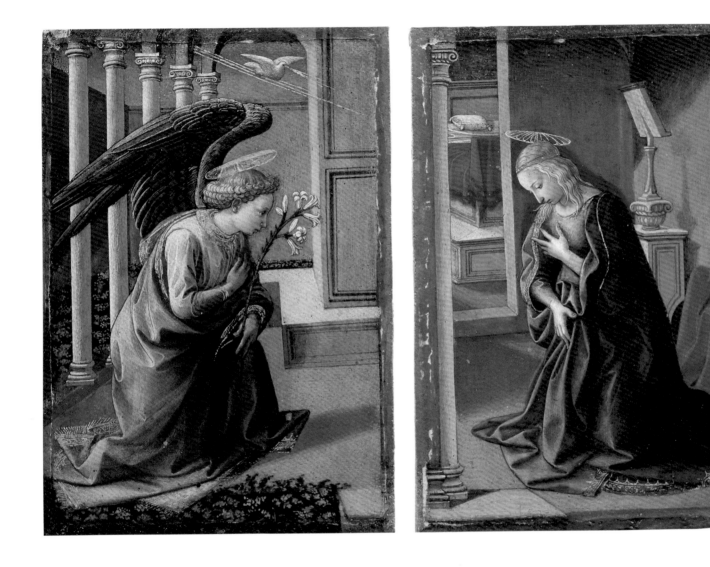

5

FRANCESCO PESELLINO (1422–1457)
A Miracle of Saint Sylvester, about 1450–3

Egg tempera on wood, 31 × 78.4 cm
Worcester Art Museum, Worcester, MA, Museum Purchase, 1916.12

DISMAYED that her son had converted to Christianity and not Judaism, the Emperor Constantine's mother, Helena, arranged a meeting with 12 Jewish philosophers and learned men to debate whose god was the true God. One of them, Zambri, declared that if he spoke the secret name of God to any living creature then that creature would instantly perish. A bull was brought in and as Zambri spoke into its ear it dropped dead. The gathering was impressed, but Pope Sylvester recognised the work of the devil. Only God, he declared, could revive the beast. When Zambri was unable to do so, Sylvester spoke a blessing, urging the bull to rise and go back to its herd. Instantly it was restored to life. All present, including Helena and Zambri, were converted to Christianity.

Pesellino set the gathering across two loggias, with Helena seated in profile at right under one and Constantine facing her at far left. The rug beneath his throne is embroidered with a motif of three interlocking rings, an early symbol of the Trinity in the Eastern church. Like many other artists of his day, for Constantine's sharp profile and the extended front brim of his hat, Pesellino drew on Pisanello's famous portrait medal of John VIII Palaeologus, the penultimate Byzantine emperor, who had visited Italy for the Ferrara/Florence Council in 1438–9.[1] Constantine's sceptre, and seemingly also the gold embroidery round his shoulders, bear the *giglio*, the heraldic lily of the Florentine Republic. Saint Sylvester kneels, his eyes raised heavenward as the resuscitated bull genuflects before him, and the gathered company reacts to the miracle.

With masterful confidence in design and execution, the Sylvester panels exhibit boldly conceived spatial arrangements, rich and carefully observed detail, dramatic foreshortening, saturated colour and delicate tonal gradations. Like the Courtauld diptych (cat. 4), they probably date to around the early 1450s, after the works made in collaboration with Zanobi Strozzi in the late 1440s (see cat. 2) and before the mature flourish of the David panels (see cat. 6). Together with two panels in the Doria Pamphilj Collection in Rome (see fig. 3), whose shorter length may indicate that they once flanked this one,[2] the work almost certainly formed part of a predella for an altarpiece featuring Sylvester prominently in the main panel. No such altarpiece by Pesellino survives, and it may be that this predella, like that of the Noviitate altarpiece

(see cat. 1 and fig. 2), is the product of a collaboration. Lawrence Kanter has suggested that two panels from a triptych today in the Hermitage in St Petersburg, depicting *Saint Sylvester Enthroned* in the larger central panel and the *Baptism of Constantine* in the left panel, may originate from the main tier of the altarpiece. Kanter's proposal is compelling, both for the subject of the Hermitage works and the division of both predella and main tier into three sections, the widest in the centre. Caution is urged by discrepancies in dimension – the predella panels are narrower than their proposed upper panels[3] – though it is possible that these might be accounted for by lost framing elements.

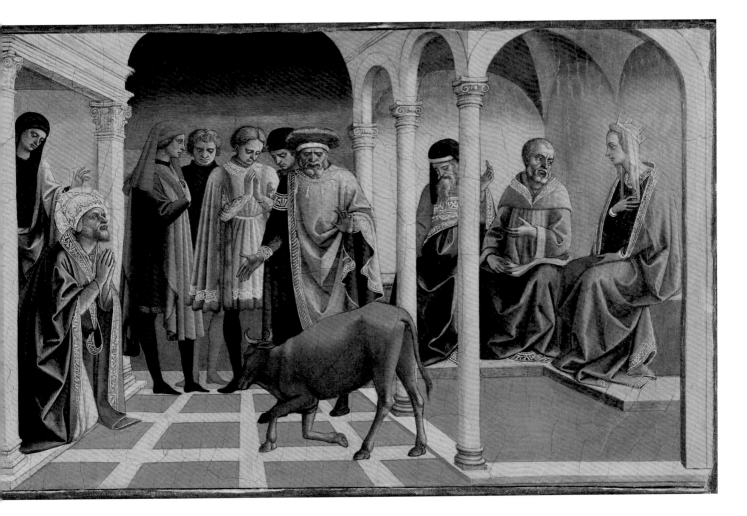

Kanter argued that the historic attribution of the Hermitage panels to Andrea di Giusto resulted from a misunderstood inscription (now lost) on their backs, and attributed them instead to a youthful Master of the Castello Nativity. The suggestion that this painter might be identified with Piero di Lorenzo Pratese, one of Pesellino's two business partners (see p. 38), has not been broadly accepted.[4] Perhaps instead Pesellino collaborated with this still unidentified artist (who was also in close contact with the workshop of Filippo Lippi), shortly before he entered the formal profit-sharing agreement with two other associates in 1453. *LL*

PROVENANCE: Prince Doria Pamphilj, Rome, by 1850; David John Carnegie, 10th Earl of Northesk (1865–1921), Ethie Castle, Arbroath, Scotland, by 1915; sold in the Northesk sale, Sotheby's, London, 1915; R. Langton Douglas, London, by 1916; sold to the Worcester Art Museum in 1916.

SELECTED LITERATURE: Davies 1974, p. 421, n. 2; Boskovits in Boskovits and Brown 2003, p. 570; Kanter in New York 2005b, pp. 284–7.

FRANCESCO PESELLINO (1422–1457)

The Story of David and Goliath and *The Triumph of David*, about 1452–5

Egg tempera on wood, 45.5 × 179.2 and 43.3 × 177 cm
The National Gallery, London
NG6579–80. Bought with the assistance of the Art Fund and a number of gifts in wills, 2000

THE attribution of these large and impressive panels to Pesellino, first proposed in the mid-nineteenth century, has never been in question.[1] They represent the painter in full force, when the vestiges of his youthful brusqueness in design had given way to assured and compelling narrative painting, underpinned by rigorous draughtsmanship and executed with near flawless technical skill, abundantly decorated with gold and silver leaf. They depict, with varying degrees of fidelity to the biblical account, episodes from the story of the shepherd boy David, the youngest of the eight sons of Jesse of Bethlehem.

The first panel shows key episodes from the story of his victory over the giant Goliath. While three of his brothers were away fighting the war against the Philistines, the young David stayed in Bethlehem to tend his father's flocks. In the upper left corner, David is seated in the tranquillity of a dawn landscape, surrounded by herds of domesticated animals as well as wild birds and beasts. Charged one morning with taking supplies to his brothers at the front, he arrived at King Saul's army encampment to find the Israelites incapacitated by the daily emergence of Goliath, the great Philistine warrior, who stepped onto the battlefield and challenged them to choose one man to fight him, and so decide the war. David volunteered, insisting that with the Lord's help he had fought off wild beasts trying to steal his flocks. Reluctantly, Saul agreed. Moving right across the panel, we see David declining armour from Saul, who is mounted on horseback and wears an imposing dragon helmet. Moving back to the left foreground, we see David again, gathering pebbles from a brook to fire from his sling.

The battlefield is shown at the centre of the panel, out in open country with tents clustered at the far right. Here, the two armies collide in combat, diverging from the biblical narrative in which David is pitted alone against Goliath. As the battle rages, Goliath stands tall – nine feet tall according to the scripture – a great monolith seemingly impervious to the fall of his comrades around him. Upon seeing David, Goliath was mockingly disdainful and swore to feed his flesh to the birds and beasts. But David declared: 'I will smite thee, and take thine head from thee' (1 Samuel 17:46). David's sling is thrown back, ready to deliver the knockout blow, but time is compressed: Goliath is already bleeding from the forehead. The narrative moves left to where Goliath lies face down, his foreshortened body straddling the stream that gushes into the foreground. David executes the fatal blow, severing his enemy's head from his body using his own sword.

The second panel – the *Triumph* – breaking with the sequential narrative of its companion, shows a single procession as the Israelite army returns victorious. Its biblical source is a few brief lines from 1 Samuel 18: 'when David was returned from the slaughter of the Philistine … the women came out of all the cities of Israel, singing and dancing, to meet King Saul'. Winding out from the hills in the upper left, the cavalcade moves into the foreground and then right, across the whole panel, to the gates of the walled city. Pesellino conceived the procession as an intricate web of mounted cavalry and foot soldiers, with densely intertwined and overlapping bodies and limbs, decked in armour and sumptuous textiles, and accompanied by dogs, falcons, a cheetah and even a bear cub. Every saddle, bridle, breastplate, rein, bit, harness, piece of armour and helmet – even some horseshoes – is carefully described using tooled metal leaf, painted over in some areas with glazes to create a panoply of decorative and light effects. At the centre of the procession are three triumphal carriages led by Saul, seated majestically in full armour. Prisoners of war are perched atop the following cart, hands bound behind their backs. On the third carriage stands David in cool triumph, brandishing Goliath's severed head by the hair. His sling hangs limply at his other side in mocking echo of his gruesome bounty. The procession is heralded by mounted trumpeters, who blow their instruments with puffed cheeks. At the far right, a group of richly dressed women emerge from the city gates to greet the conquering army. *LL*

PROVENANCE: probably Palazzo Medici, Florence; certainly Palazzo Pazzi by 1822; in the collection of Marchese Luigi Torrigiani from at least 1869; in Britain by 1896, when sold to Lord Wantage (Loyd Collection) through Agnew's; on long-term loan to the National Gallery from Loyd Collection from 1974, then acquired in 2000 (with a contribution from the Wolfson Foundation).

SELECTED LITERATURE: Ames-Lewis 2000; Gordon 2003, pp. 288–95; Staderini in Florence 2010, cat. 26, pp. 246–51; Silver 2012, pp. 256–87.

TECHNICAL FINDINGS

The cleaning and restoration of the David panels provided the stimulus both for the exhibition this catalogue accompanies, and for a detailed technical examination, including the application of recently introduced imaging techniques.[2] Together with the recovery of much original paint and gold and silver leaf from beneath a heavy and badly darkened old restoration, these methods have resulted in new insights into the remarkable invention and craftsmanship that went into the making of these sumptuous panels.

As is often the case, past treatment of the wood of the panels has compromised the available information as to their original construction and function.[3] Nevertheless, X-rays reveal that each was constructed by gluing together two long narrow boards, almost certainly of poplar. Inevitably, given their length, there are knots and flaws in the timber which now show as slight distortions on the paintings' surface. The removal of later imitation gilding and white filling (gesso) from around the edges has revealed wooden borders that were once covered by carved mouldings. A raised edge (*barbe*) to the gesso grounds on the panels confirms that the flat surfaces were prepared at the same time as the mouldings. At the centres of the upper edges of the borders (almost certainly trimmed) are two small pieces of relatively modern wood, plugging holes in the panel which must originally have been cut into the wood for the insertion of keys. While they seem surprisingly close to the painted surfaces, the locations of keyholes in cassoni (chests) seem to vary considerably, and in this case were probably determined by the profiles of the chests' mouldings. Any evidence as to the extent to which these chests were assembled before they were handed over to the painter is lost.

The techniques Pesellino used in depicting the story of David and Goliath are mostly conventional for Florentine panel painting of the period. What makes the panels exceptional is their complexity of design and the refinement and detail of their execution. Drawing played a central role in Pesellino's work (see pp. 10, 17–18, 34 and cat. 3) and these paintings must have required extensive preliminary study, both in planning the complex compositions, especially the episodic scenes in the *Battle*, and in the assembling and making of detailed studies on paper for the most prominent of the hundreds of figures and animals. Every element of the compositions, however small, was then drawn on the white gesso with liquid black paint or ink applied with a fine pointed brush (fig. 40). The modelling of draperies was often indicated with minutely hatched parallel lines of shading. This underdrawing is revealed in places by infrared imaging (fig. 41), but it can sometimes be difficult to distinguish from hatched shading connected with the final touches of the painting stage. In addition, it is completely obscured when covered by gold and silver leaf.

Fig. 40 Photomicrograph of the *Battle*, revealing underdrawing showing through red paint and the use of black details to emphasise features, even for small figures in the background

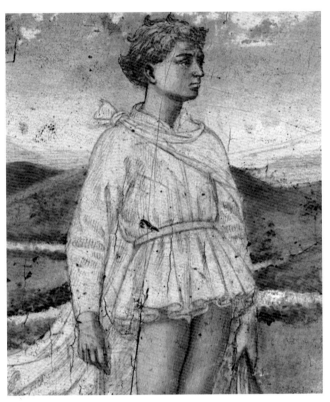

Fig. 41 Infrared reflectogram of David in the *Triumph*, showing shaded underdrawing in his tunic

While Pesellino was evidently remarkably careful in planning his paintings, the extensive use of decoration with metal leaf in such complex compositions meant it was imperative to determine the design at an early stage. Since the pieces of gold and silver and the red-brown clay (bole) that underlies them would cover any drawing, all the outlines and details of the underdrawing in areas to be gilded or silvered were first fixed by fine incisions into the gesso. The laying of the pieces of gold leaf, and then the silver leaf, over the bole in the relevant areas was so complicated and specific that it seems unlikely that Pesellino delegated this task to a specialist gilder. The shape of the splendid dragon helm worn by King Saul in both panels, for instance, is patched together from multiple scraps of gold leaf (figs 42, 43), while tiny details such

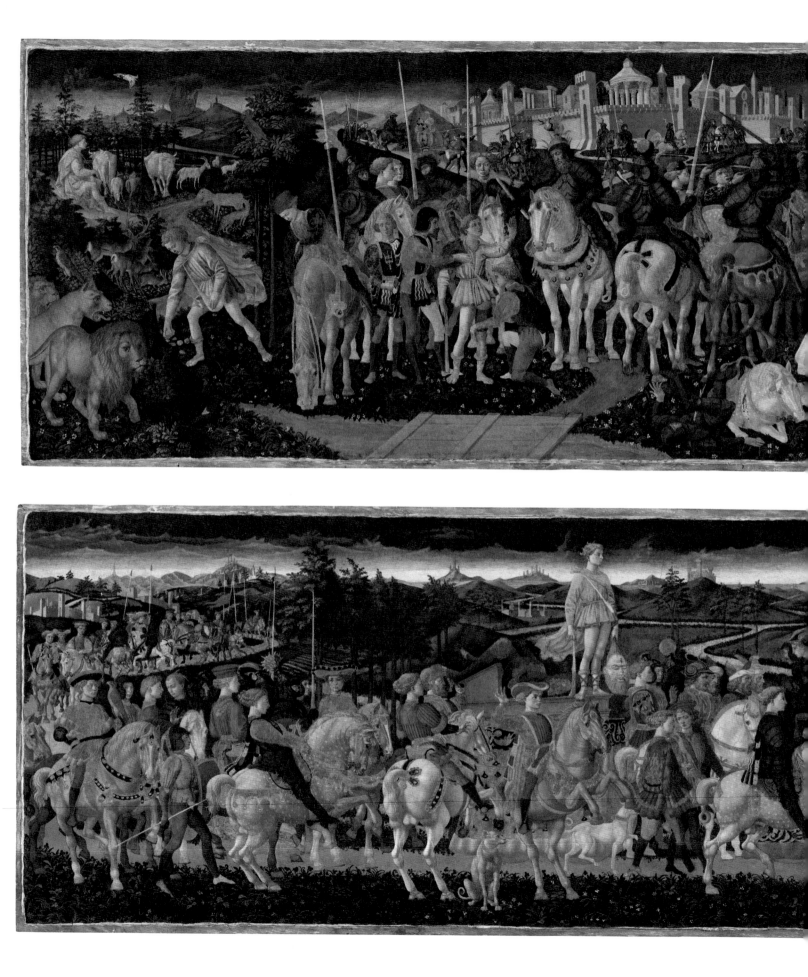

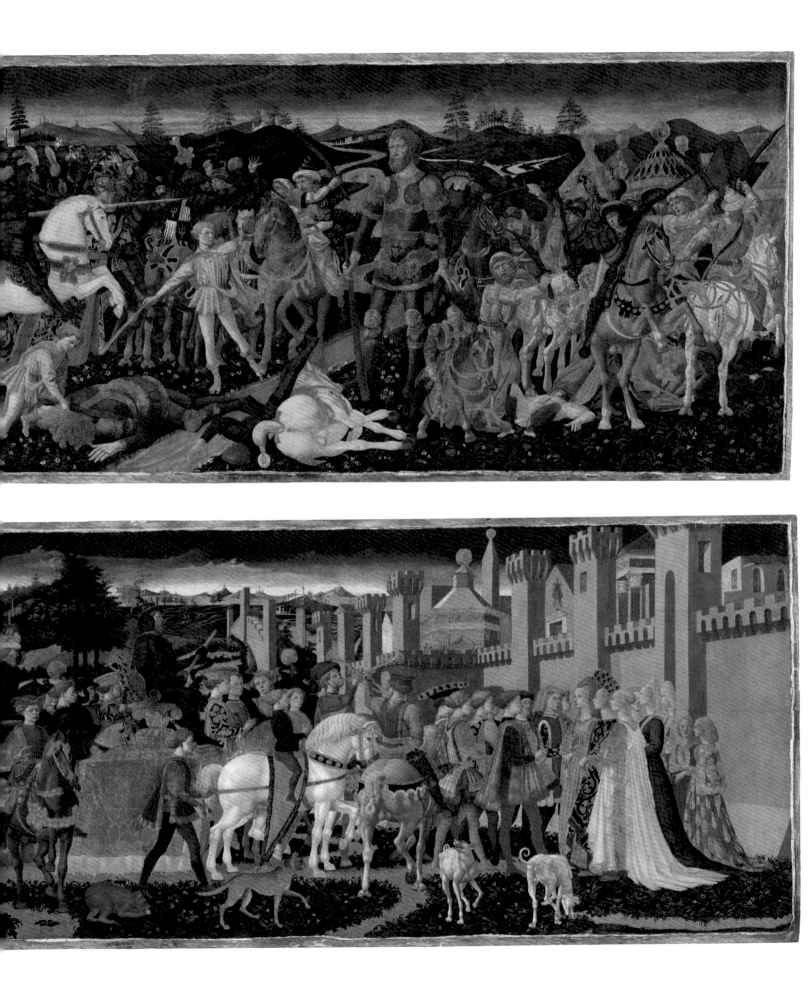

as horseshoes, bits and spurs called for equally small pieces of silver leaf. Inevitably, these pieces of metal leaf extend beyond their drawn and incised contours and the tarnishing of the silver means an unintended dark shadow can often now be seen through the paint of the overlapping forms (fig. 45). Where the gold leaf extended under areas to be painted, Pesellino often covered this excess with a layer of lead white, again an orthodox process.

The gold leaf was highly burnished with an agate or other smooth burnishing tool, and the fact that it has retained much of its reflective quality means that the tooling of the surface with punches and a fine stippling tool retains most of its original impact, especially where Pesellino stippled the lit side of a gilded shape, for example the golden spheres or the wide-brimmed hat of the young man who precedes Saul in the *Triumph*. Further decoration was achieved by inscribing lines with a slightly blunt stylus, which indented the gesso without damaging the gold. These were mainly to represent shimmering threads in cloth-of-gold fabrics or the shafts and barbs of feathered patterns and plumes. Originally, these patterns included colours painted over the gold and silver, but these

survive only partially and in places are likely to have flaked away without trace. The plumes worn by the helmeted knights, displaying the Medici colours of pink, white and green (see p. 27), were painted over the gold with both opaque paints containing a high proportion of lead white and a more translucent green containing copper (now discoloured) (fig. 44). In other details, the translucency of pure red lake pigments enabled Pesellino to achieve enamel-like decorative effects by applying them over the reflective gold leaf (fig. 46). Some figures were dressed in silver textiles patterned with green, now barely detectable because of darkening of both the green and silver (figs 48, 49), but the silver armour of many of the knights, while damaged, remains surprisingly legible. This is because Pesellino modelled over the silver with grey and black paint to depict the structure of the armour and suggest the dark gleam of steel. There are indications that here he may have used some oil (not surprising by this date) as a binder, especially for the deep black lines of detailing, but essentially the painting was executed in the traditional Florentine medium of egg tempera.[4]

The flesh tints were delicately hatched over a pale base layer containing lead white and a little green earth, the

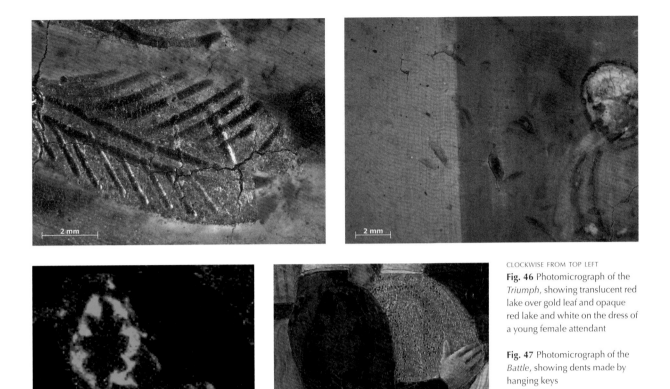

Fig. 46 Photomicrograph of the *Triumph*, showing translucent red lake over gold leaf and opaque red lake and white on the dress of a young female attendant

Fig. 47 Photomicrograph of the *Battle*, showing dents made by hanging keys

Figs 48, 49 Detail of a horseman's sleeve in the *Triumph* and the corresponding X-ray fluorescence map of copper (in green) and silver (in white), showing the painted pattern, originally green over the silver leaf, now barely visible

modelling always following the direction of light so that highlights fall on the backs of most of those in the procession in the *Triumph*. Some of the figures engaged in the fighting on the right of the *Battle* have their features emphasised with black for expressive effect. The range of pigments is standard for the time, consisting of lead white, black, red and yellow earths, vermilion, red lake, lead-tin yellow, ultramarine (for the blue costumes) and the blue and green copper mineral pigments azurite and malachite. These were used particularly in the skies and landscapes. For maximum intensity of colour these minerals needed to be coarsely ground. When used pure, without any lead white, they can cause the surrounding egg medium to discolour, a phenomenon that might have contributed to the dark, almost black, appearance of the upper parts of the azurite skies. Similarly, there is a loss of brilliance in the landscapes and other details painted with malachite. The flower-strewn meadows in the foreground, however, were always quite dark, having been underpainted with a solid black layer, a technique seen in Florentine painting of the previous century that continued to be used by later artists such as Botticelli. Here, the foliage has become less visible,

having been painted with malachite, and the flowers, many with pink and blue centres, are reduced in colour. The colours in the David panels should perhaps be imagined as close to the high-key brilliance of those still evident in Pesellino's beautifully preserved manuscript paintings (see figs 4–6).

In addition to alteration of the materials with time, the surfaces of the panels exhibit types of damage generally associated with cassoni – an inevitable consequence of their vulnerable location. As well as long deep scratches, scuffs and the apparently deliberate disfiguring of faces (often attributed to small children), both panels have areas of damage in the central upper parts consisting of numerous small dents, now mostly filled with residues of old varnish and dirt (fig. 47).[5] Such damage has been noted on other panels from cassoni and must have been caused by the swinging of keys left dangling from the locks. Although exceptionally large and splendid for this type of furniture painting, it seems, therefore, that this was their original purpose. Pesellino's extraordinary commitment to design and execution throughout the David panels may be explained by the importance of their patron (see pp. 30–2). *JD*

7

FRANCESCO PESELLINO (1422–1457)
Virgin and Child, about 1455

Egg tempera on wood, 59 × 34.9 cm
Lyon, musée des Beaux-Arts, inv. 1997-4

PESELLINO was a key actor in the rapid development of painted half-length Virgin and Child groups in Florence in the middle decades of the fifteenth century. This is one of three autograph iterations of the theme whose designs were subsequently widely proliferated by the so-called Lippi Pesellino imitator(s) (see pp. 38–41).[1] It shows the Virgin seated before a carved niche, with the Christ Child perched on a ledge in front of her, to her left. Supporting the infant with two delicate hands, she extends a tender finger to caress his cheek. The child is positioned frontally, with chubby legs planted in a steady contrapposto and wide eyes which gaze out at a point beyond the viewer.

The niche, whose contours reveal a number of visible incisions made in the gesso at the design stage, is opulently rendered as variegated marble, with a conch shell dome and gold horizontal mouldings. Like his elder painter contemporaries, such as Paolo Uccello and Fra Filippo Lippi, in his use of the niche Pesellino was evoking sculpted depictions of the Virgin and Child.[2] In spite of the shallow depth of field and the waifish form of his Virgin, Pesellino's determination to resolve the figures' spatial relationship to the niche is notable. Earlier painted examples show the figures enclosed within the framing niche. By depicting the ledge upon which Christ stands as a truncated shelf, as opposed to a lintel spanning the base, Pesellino was able to show, summarily but effectively, the Virgin's legs tucked beneath it. He also angled the Virgin's body towards the viewer, with the left shoulder set back and the right protruding forward. Finally, he placed her halo in front of, as opposed to within, the framing arch.[3]

For such devices to position the Virgin's body effectively in space, he may have been looking to Luca della Robbia's mother and child groups in glazed terracotta. In mood too, Pesellino seems to be responding to the serene monumentality of these works. In particular, the figure types, with their crisply defined and sharply straight contours, chiselled features and stylised curled hair, belong to a della Robbian idiom, and so too the Virgin's attire, in particular the veil that is gathered in a loose loop round the neck. *LL*

PROVENANCE: Edouard Aynard Collection, Lyon; sold at the Aynard sale 1–4 December 1913, Galerie Georges Petit, Paris, lot 43; private collection, France; sold to Musée des Beaux-Arts de Lyon in 1997.

SELECTED LITERATURE: Gronau 1938, p. 137, fig. 5; Davies 1961, p. 186; Berenson 1963, vol. 1, 168 and vol. 2, fig. 834; Zeri 1976, vol. 1, p. 83; Laclotte and Mognetti 1977, no. 267; Shapley 1979, vol. 1, p. 226, no. 646.

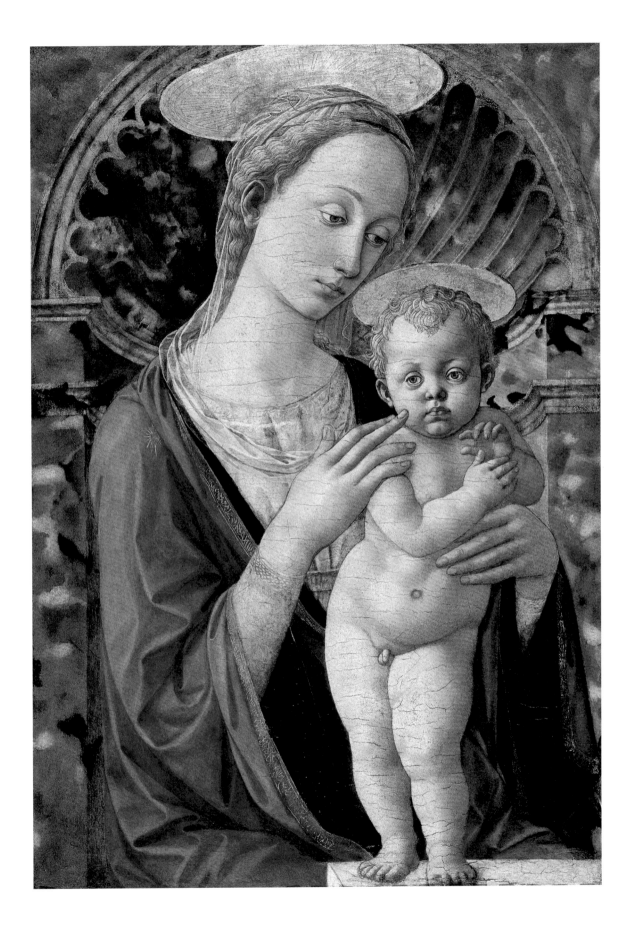

8

FRANCESCO PESELLINO (1422–1457), FRA FILIPPO LIPPI (born about 1406; died 1469) and workshop
The Pistoia Altarpiece
The Trinity with Saints Mamas, James, Zeno and Jerome; Saint Mamas in Prison thrown to the Lions; The Beheading of Saint James the Great; Saint Zeno exorcising the Daughter of Gallienus; Saint Jerome and the Lion, 1455–60

Egg tempera, *tempera grassa* and oil on wood, main panel about 185 × 181 cm, predella panels approximately 27 × 39 cm each
The National Gallery, London
L15 (Mamas, James). The Royal Collection / HM King Charles III; NG3230 (left-hand angel). Bought, 1917; NG727 (Trinity). Bought, 1863; NG3162 (right-hand angel). Bequeathed by Countess Brownlow, 1917; NG4428 (Zeno, Jerome). Presented by the Art Fund in association with and by the generosity of Sir Joseph Duveen, Bt, 1929; NG4868.1–4 (predella panels). Presented by Mr and Mrs Felix M. Warburg through the Art Fund, 1937

IN 1455 a confraternity of priests commissioned an altarpiece for their chapel in Pistoia, a provincial city in Florence's territory. Altarpieces by imported artists were more expensive than those by their local counterparts, and before any other decisions were made, the Pistoia priests agreed to spend 150–200 florins, a substantial sum appropriate to the 'honour' they required it to reflect.[1]

Control of the diocese belonged to the Florentine Bishop Donato de' Medici (1407–1474). In Pistoia, and possibly neighbouring Prato too, Donato diligently promoted artists with Medici connections.[2] His branch of the family had long done so, even hiring Pesello to paint banners for the funeral of Donato's grandfather Vieri di Cambio de' Medici (1322–1395), a leading banker and office holder in the *comune* of Florence.[3] Donato probably heard of Pesellino from his second cousin Piero di Cosimo de' Medici, an individual closely familiar with the painter's work. Piero was eventually chosen to judge the altarpiece's final value, which suggests that the priests may have had concerns about Pesellino's inexperience painting altarpieces.[4] In any case, they decided on Pesellino with remarkable speed, signing a contract with him within only one week of their initial meeting.

Pesellino's finely detailed drawings allowed the confraternity to make decisions from afar. Expenses claimed by the committee, who subsequently went to Florence to sign the contract with Pesellino, included a reimbursement to the priest Pero for writing paper and the drawings 'he had had made'.[5] Michelle O'Malley has convincingly argued that these were Pesellino's preliminary proposals.[6] Two surviving drawings relate to the altarpiece and one of them can plausibly be identified with this pre-commission stage. The small drawing in the Uffizi shows Saints Zeno and Mamas – respectively the patron of Pistoia and one of the priests' favoured saints – together as an overlapping pair, executed

in black chalk over traces of stylus, heightened with white lead (fig. 51). Zeno holds a staff and a book while Mamas, also holding a book, gestures with his open right hand towards the notional centre of the composition. Several of these ideas were retained at the painting stage, redistributed to different figures.

Pesellino made another drawing, now in St Petersburg, in preparation for the Trinity. He focused on God the Father, studying the fall of drapery and relying on contours alone to envision the Crucified Christ, which he probably studied separately. As in the previous sketch, the use of white lead suggests that he intended to share it, perhaps with his clients. The Trinity was the confraternity's emblem ('nostro segnio') and its priests no doubt held strong, if varying, opinions on how it should look. Their feedback may have driven Pesellino to make slight adjustments, transforming God from the world-weary father in this drawing into the painting's triumphant deity.

While Pesellino seems to have executed the design of the entire altarpiece and to have painted at least some of it, including Saints Mamas and James, he probably finished little of the landscape.[7] It has been observed that the foreground is painted with artificial malachite over a layer of black pigment, while the background is painted with thin, now mostly oxidised, copper-based green glazes.[8] The contrast of thick green foreground foliage with a thin brown background most closely resembles Pesellino's David panels. Dillian Gordon has pointed out that Fra Filippo Lippi sought to conceal the convergence of their two styles in the landscape. Indeed, the river terminates incongruously behind the foreground. The perceived discontinuity is probably a result of Pesellino's innovative original design, which alludes to the miraculous nature of the Trinity, as well as Lippi's completion of the painting.

Unlike Pesellino's Louvre altarpiece (see fig. 13), very little of *The Trinity with Saints* outwardly resembles the work of Lippi or Domenico Veneziano even though, uniquely, they were both

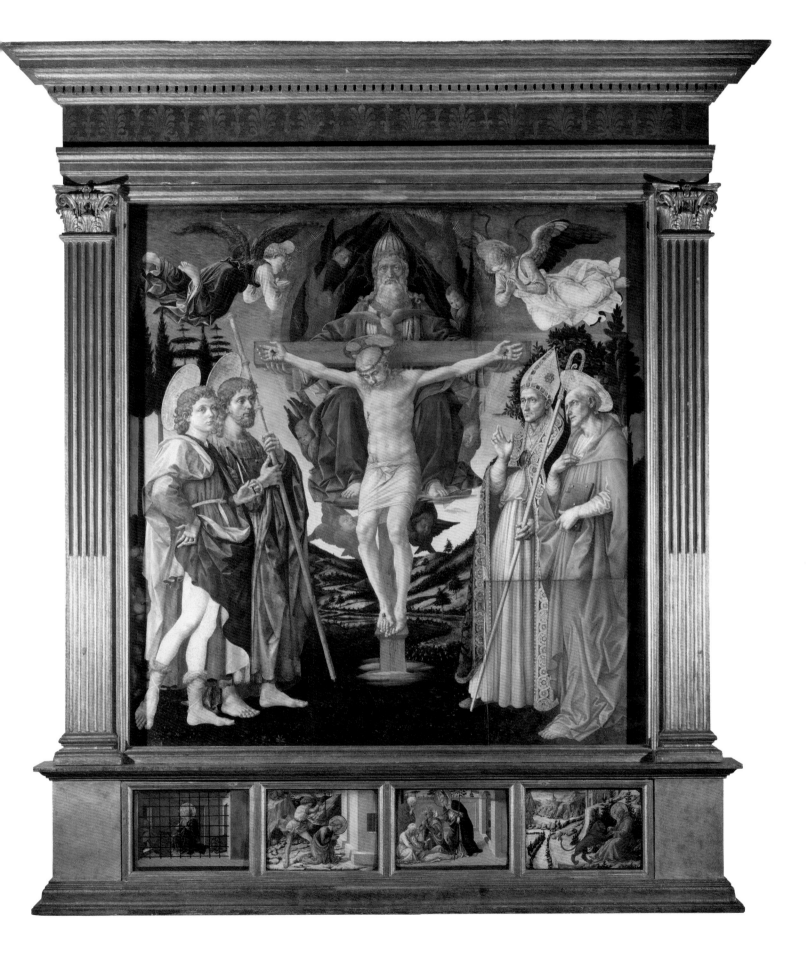

Fig. 50 Fra Filippo Lippi (about 1406–1469)
Madonna della Misericordia, 1460
Egg tempera on wood, 100 × 228 cm
Formerly Staatliche Museen zu Berlin, Gemäldegalerie

involved in it. In July 1457, when Pesellino became too ill to continue work, the confraternity paid a notary who witnessed a valuation of the painting by Lippi and Domenico Veneziano.[9] Both distinguished painters of an older generation were experienced in painting large *all'antica* (classically inspired) altarpieces that Pesellino had turned to for inspiration. But the task of evaluating a work of art was usually given to persons who had a previous working relationship with the artist. Pesellino had painted the predella for the Lippi altarpiece in the Novitiate Chapel of Santa Croce (see cat. 1 and fig. 2) and the design of the window there has been attributed to Domenico Veneziano.[10]

In contrast to Piero di Lorenzo Pratese, Pesellino's *compagno* (see p. 38), Lippi was neither Pesellino's business partner at the time of his death nor a convenient choice to finish the altarpiece, but his appointment attests to their earlier collaborations.[11] On the basis of technique and paint sample analysis, Gordon has argued that Lippi or someone in his workshop – not Pesellino – painted Saints Zeno and Jerome. However, the difference is not immediately visible to the naked eye.[12] Lippi's style was clearly compatible with Pesellino's and he may already have executed at least one small-scale painting to Pesellino's design, as noted in the 1492 Medici inventory (see fig. 11).

The 115 florins that Lippi received in payment was also compensation for his work on the five-part predella. But Lippi arguably responded to Pesellino's altarpiece in one further way. The predella matches the length of the lost *antependium*, or altar frontal, that was originally installed beneath it and which

was commissioned from Lippi in 1460 by the confraternity (fig. 50). It depicted the Virgin of Mercy, complementing the imagery of the altarpiece. The tightly packed crowd of 41 individuals around her may well have included a portrait of Pesellino. While many of the faces are clearly idealised, a few appear to be more veristic, including the only one that gazes directly out at the viewer beneath the angel at the far left. Flanked by a youth and an older man who both cast their eyes down as if in mourning, this young man is clearly not a priest and wears a soft hat turned up at the brim not unlike those donned by artists in Benozzo Gozzoli's Medici chapel fresco of the Magi. He seems too young to be Lippi. Could he be Pesellino?

In the eighteenth century, Pesellino's single panel was sawn into at least five pieces to facilitate sale. William Young Ottley, a pioneering scholar and collector of Italian primitives, brought three back to England, where the biggest entered the nation's nascent collection. Others were eventually acquired from private collections and reassembled, including that of Prince Albert who possibly gave one fragment to his favourite daughter, Princess Victoria; this may explain why it turned up in the private chapel of her son, Kaiser Wilhelm II. When it entered the National Gallery's collection in 1929, this final fragment was missing its bottom third, and an addition based on the Frankfurt drawing (fig. 36) was painted to integrate it into the overall ensemble.[13] *NS*

PROVENANCE: Commissioned in 1455 by the Compagnia della Santissima Trinità for their church of the Santissima Trinità, or San Jacopo, in Pistoia; described in 1821 as sold to a foreigner, presumably William Young Ottley (1771–1836). For the full provenance of each fragment, see Gordon 2003, pp. 280–2.

SELECTED LITERATURE: Bacci 1944, pp. 111–51; Gordon 2003, pp. 260–87; Staderini 2013.

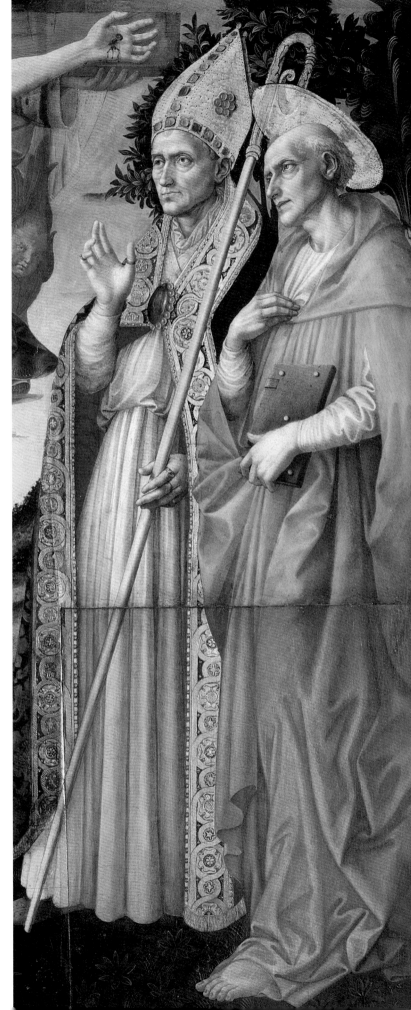

Fig. 51 *Saints Zeno and Mamas*, about 1455
Black chalk heightened with white lead on paper, 25.3 × 10.5 cm
Gabinetto dei Disegni e delle Stampe, Gallerie degli Uffizi,
Florence, inv. 164F (recto)

NOTES

A master painter overlooked

*My thanks to Alison Wright for sage advice and careful guidance in pursuit of Pesellino, to Carl Brandon Strehlke for his thoughtful comments on an early draft and to Laura Llewellyn for the invitation to write for this catalogue.

1. 'Life of Pesello and Pesellino', Vasari 1878–85, pp. 35–40. For a recent study of Pesellino, see Silver 2012.
2. Milanesi 1860, pp. 205–7.
3. Molho 1994 observed that not one of the several hundred people who worked the Medici lands between 1427 and 1458 appears in the registers of the Monte delle Dote (the state dowry fund). Whether or not this was standard practice is unclear but it suggests that the Medici provided dowries for family employees.
4. In 1427 a *fanciullo di bottega* (workshop boy) named Corso was recorded in Pesello's workshop. By 1433 his name was gone, suggesting that Francesco had taken his place. See Even 1984, doc. 1.
5. In 1433 Pesellino is first reported as his son: 'franc° figliuolo danni 11' (Franc[esc]o his son age 11); ASF 1433, fol. 581v. Pesellino has never been convincingly identified in the extant guild registers, despite the extensive research of Horne [about 1907–] (manuscript notes) and Procacci 1960.
6. Artists also saved on the cost of indenture by apprenticing a family member.
7. Even 1984, p. 186, doc. 13.
8. Krautheimer 1956, doc. 7. Pesello made the glass mosaic frieze decorating the marble niche containing Ghiberti's *Saint John the Evangelist* at Orsanmichele.
9. Another example of the same period is Lippi's Martelli Altarpiece. It is often dated to around 1440–2 and its predella is typically attributed to Giovanni di Francesco who, like Pesellino, worked for Lippi and similarly seems to have had significant experience (for the date, see De Marchi in Bietti 2018, p. 141; Rowley in Bietti 2018, p. 159). In 1440, Lippi paid Giovanni 40 florins to 'obey in the manner of a discepolo', a sum reflective of his considerable experience (for the document, see Ruda 1993, pp. 520–1). Both Ruda and Holmes 1999, p. 151 distinguish Giovanni from other 'garzoni' and 'discepoli' in Lippi's workshop by the salary, the duration of his contract, and the fact they formed a legal *compagnia* in 1442. If the term 'discepolo' was applied to mature and experienced painters, including Fra Diamante, it raises an important question: what did they hope to learn in Lippi's employ?
10. Gronau 1938, doc. 2.
11. Nearly twenty years after his death, Pesello was remembered as the author of painted silk banners ('lavorate di mano di Pesello') owned by Francesco di Matteo Castellani and lent to Maso di Niccolò d'Ugo degli Alessandri; Castellani 1995, p. 117.
12. They were Bartolo di Domenico Corsi, Guidetto di Jacopo Guidetti and Giovanni di Bernardo Altoviti.
13. Shearman 1983, pp. 194–6. This Coronation incorporates an Annunciation scene – divided into two parts – that imitates the Courtauld panel in format, composition and style.
14. Strehlke 2004, p. 356. The New York painting's results of infrared reflectography remain unpublished and I thank Charlotte Hale for examining them with me on 28 February 2011.
15. Bambach 1999, p. 235.
16. For an entry on the Zagreb panel, see Zlamalik 1982, pp. 56–7. The second copy is Lippi Pesellino imitator, *The Mystic Marriage of Saint Catherine*, 48.3 × 27.9 cm, egg tempera on wood, sold Sotheby's, London, 15 July 1931, lot 116.
17. For the passage in Francesco del Pugliese's second last will and testament, see Burke 2004, p. 159. The Pesellino painting has never been identified. The Botticelli is *The Last Communion of Saint Jerome* (The Metropolitan Museum of Art) and two saints by Filippino Lippi (Pushkin State Museum of Fine Arts, Moscow) that flanked a *Head of Christ* attributed to the Master of the Legend of Saint Ursula (Museo Patriarcale, Venice), and a *Last Judgment* by Fra Angelico (possibly Palazzo Corsini, Rome) flanked by two saints by Botticelli (State Hermitage Museum, St Petersburg).
18. The inventory of Palazzo Medici drawn up two years before Lorenzo Il Magnifico's death survives in the form of a copy, made in 1512. Hereafter any reference to the 1492 inventory refers to this copy. For a recent study of the inventory, see Stapleford 2013.
19. Spallanzani and Bertelà 1992, p. 33.
20. For a summary of its critical history, see Labriola in Florence 2005, pp. 104–5.
21. For the villa, rock and church, see Lillie 2007.
22. For a recent entry on the version of *Saint Jerome in the Wilderness with a Friar* (Accademia Carrara, Bergamo) attributed to the Lippi Pesellino imitator, see Staderini in Valagussa 2018, pp. 44–6.
23. Filarete (1464) called him a 'grande maestro danimali'; Spencer 1965, vol. 2, p. 62. The 1492 Palazzo Medici inventory, the *Libro di Antonio Billi* and the Anonimo Magliabechiano all single out his paintings of animals for the Medici, but attribute them, incorrectly, to Pesello. See Frey 1892a, p. 27; Frey 1892b, pp. 100–1; Spallanzani and Bertelà 1992.
24. The number climbs over ninety when also counting horses implied by further sets of legs.
25. Schubring 1915, vol. 1, p. 246; Ames-Lewis 2000, pp. 198–203.
26. Gordon 2003, p. 291 proposes a date between 1439–45 and 1455; Ames-Lewis 2000 proposed the mid-1450s; Laclotte 1978 suggested a date around 1455.
27. Gordon 2003, pp. 271–3.
28. For Pesellino's role in this revolution of domestic furnishings, see Silver 2019.
29. 'Uno panno sopra l'uscio della sala, di br. 4, corniciato intorno et messo d'oro, dipintovi dentro et lioni nelle gratichole, di mano di Francesco di Pesello, f. 4' (A canvas above the room's exit, of 4 braccia, enclosed in a gold frame, within which is painted lions in a cage by the hand of Pesellino); Spallanzani and Bertelà 1992, p. 26. For references to it in subsequent inventories, see Bulst 1990, p. 113, n. 226.
30. Wright 1993, p. 140.
31. 'Sei quadri chorniciati atorno e messi d'oro sopra la detta spalliera et sopra al lettuccio, di br. 42 lunghi e alti br. iii ½, dipinti c[i]oè tre della Rotta di San Romano e uno di battaglie di draghi et lioni, et uno della Storia di Paris di mano di Pagholo Uccello e uno di mano di Francesco di Pesello, entrovi una chaccia, f. 300' (Six pictures framed with gold, above the said spalliera and above the daybed, 42 braccia long and 3.5 braccia high, three depicting the Battle of San Romano, one of a battle of dragons and lions, and one of the story of Paris by the hand of Paolo Uccello, and one by Pesellino depicting a hunt); Spallanzani and Bertelà 1992, p. 11.
32. See Gordon 2003, pp. 378–97.
33. Lorenzo's *camera grande terrena* had previously been used by his grandfather Cosimo de' Medici who moved into the Palazzo between 1451 and 1457. On the reuse of this room, see Bulst 1970, pp. 390–1 and Bibby 2007/8, p. 16. For a discussion of the lost paintings, see Borsi and Borsi 1992, pp. 329–30. For this discovery, see Caglioti 2001.
34. For Zanobi di Migliore, see Jacobsen 2001, p. 643 and Santi 1976, p. 26; for Piero di Lorenzo Pratese, see Jacobsen 2001, pp. 622–3.
35. Thanks to Elisabeth Ravaud for sharing with me the results of the 2009 campaign of infrared reflectography.
36. Cadogan 2007, p. 771, who characterises the drawing as an 'early example of … specialised head study … associated with the increasing production of cartoons in the second half of the quattrocento'.
37. New York 2005a, pp. 138–43.
38. See Venturini 1994, p. 100.
39. See Gordon 2003, pp. 142–55.
40. Vasari 1878–85, p. 36. For Castagno's collaboration with Pesello on the 1444 funeral of Leonardo Bruni, see Spencer 1991, p. 80. Spencer incorrectly transcribed 'Pesellino' as painter of the banners. It was actually Pesello, which is clear from Herbert P. Horne's transcription of the relevant documents.

Pesellino and the Medici palace

1. 'con cornice rossa filettata d'oro'. My sincere thanks to Fabio Gaffo for generously sharing his research on the Pazzi inventories in advance of its publication. His article 'Tra mobili e immobili: la *Madonna Pazzi* e altre opere di famiglia' is forthcoming.

2 'faccia anteriore di un cassone'; for the 1869 inventory, see Catalucci 2014, p. 138 (fol. 39r), no. 50; 'deux magnifiques panneaux de bahuts, qu'on appelle cassoni' (with attribution to Benozzo Gozzoli): see Ostoya 1884, p. 300. The panels arrived in Britain at the end of the nineteenth century (1896), when they were sold to Lord Wantage (Loyd Collection) through Agnew's; see Gordon 2003, p. 292. On long-term loan to the National Gallery from 1974, then acquired in 2000 (with a contribution from the Wolfson Foundation).

3 Gerulli 1933, p. 88; Gordon 2003, p. 291; Randolph in Boston and Sarasota 2008–9, p. 21; Musacchio in ibid., p. 35.

4 For the preponderance of battles and triumphal processions on conjugal furniture paintings, see Witthoft 1982, Baskins 2002, p. 124 and Baskins in Boston and Sarasota 2008–9, pp. 5–13. Baskins 1993, pp. 117–20 noted the emphasis on the reward of marriage (to a royal bride) in the biblical account of David's defeat of Goliath and suggested that the fifteenth-century viewer likely associated the image of David with the ideal nuptial reward.

5 The word 'cassone' is typically used by scholars today, but painted and lockable chests were called, among other things, *forzieri* in fifteenth-century documents. See London 2009, pp. 12–14; Staderini in Florence 2010, pp. 55–6.

6 On this type of damage, which is distinct to cassone panels, see Callmann 1999, pp. 341–2.

7 For the attribution history of the Birmingham, AL panels, see Boston and Sarasota 2008–9, cat. 1, p. 99.

8 Silver, in this publication, makes a case for the paintings having originally been spalliere (see pp. 34–5). Boskovits and Brown 2003, p. 6, n. 15; Gordon 2003, p. 291; Silver 2012, pp. 263–4, 270; Silver 2019, pp. 43–5.

9 For these accounts (*Libro di Antonio Billi* and *Codice dell'Anonimo Magliabechiano*), see p. 37 in this publication. Both accounts prefigure Vasari in confusing Pesello and Pesellino. Pierfrancesco had been orphaned in 1440 and subsequently raised by his uncle, Cosimo.

10 For later derivations, see Ames-Lewis 2000, p. 191, nn. 3, 4; Callmann 1974, p. 39, n. 4.

11 Musacchio 2008, p. 143 observed that painted chest frontals range on average from 127 to 165 cm in length; see also Callmann 1974, p. 27, n. 12.

12 Examples include a pair of panels by Apollonio di Giovanni depicting stories of the Queen of Sheba in the Birmingham Museum of Art, AL (61.95) and the Museum of Fine Arts, Boston (30.495): see Callmann 1974, p. 64, nos 24, 25; and two panels by the Master of Marradi at Harewood House, West Yorkshire: see London 2009, p. 100.

13 Ames-Lewis 2000.

14 On the lions of the Loggia dei Lanzi, see ibid., p. 202, n. 57.

15 See Butterfield 1995, pp. 115–33. On the imagery of David in Florence, see also pp. 42–3 in this publication.

16 On Piero's falcon *impresa*, see Ames-Lewis 1979, pp. 134–40; Koch 2010.

17 For Pesellino's knowledge of the tondo, see also cat. 8. On Pesellino and Domenico Veneziano, see p. 38 in this publication.

18 See also Gerulli 1933, pp. 89–90.

19 Lurati 2021, p. 232. On Piero de' Medici's taste for, and emulation of, the art of the Northern Italian courts, especially Ferrara, see Groom 2018, pp. 169–72 and Kent 2000, p. 259.

20 'E lavorò in casa de' Medici una spalliera d'animali, molto bella; ed alcuni corpi di cassoni, con storiette piccole di giostre di cavalli: e veggonsi in detta casa sino al dì d'oggi, di mano sua, alcune tele di leoni, i quali s'affacciano a una grata, che paiono vivissimi: ed altri ne fece fuori; e similmente uno che con un serpente combatte: e colorì in un'altra tela un bue ed una volpe, con altri animali molto pronti e vivaci.' Vasari 1878–85, p. 37.

21 See e.g. Ames-Lewis 2000, p. 194.

22 For these sources, see n. 9 above.

23 Silver 2012, p. 279 observes that Vasari described Uccello's *Battle of San Romano* as 'istorie di cavalli' and that even earlier sources identify them as jousts.

24 For the dispersal of the Medici collection after the death of Lorenzo 'il Magnifico', see Musacchio 2003. See also Fusco and Corti 2006, pp. 159–77.

25 Vasari spent part of his boyhood in Florence taking his lessons alongside the cousins Alessandro and Ippolito de' Medici, so likely gained access to the palace where they lived at this point; see Rubin 1995, pp. 10, 71–3.

26 Musacchio 2008, p. 137.

27 On the date of the David panels, see also p. 20 in this publication.

28 Staderini in Florence 2010, pp. 246–51 (Musée de Tessé, Le Mans, inv. 10.20 and 10.21; Harvard Art Museums, Cambridge, MA, inv. 1916.495 and Nelson-Atkins Museum of Art, Kansas City, inv. 32.82).

29 'paio di forzieri messi d'oro di br. 3 ½ l'uno dipintovi dentro e Trionfi del Petrarcha'. The proposal, made by both Weisbach 1901, pp. 75–83 and Hendy 1931, pp. 254–74, has been reiterated by numerous scholars since: see e.g. Bellosi 1990, p. 125, fig. 82; Staderini in Florence 2010, p. 116. For further references, see Colby in Boston and Sarasota 2008–9, p. 109, n. 4.

30 Musacchio 1999, p. 77 and n. 90; Colby in Boston and Sarasota 2008–9, p. 109, n. 4 rejected this proposal partly on the basis of Apollonio di Giovanni's workshop book recording an order for 'due forzieri' for Pierfrancesco de' Medici in 1455, apparently confusing this patron with his cousin Piero di Cosimo de' Medici. For the workshop book, see Callmann 1974, pp. 35, 79, no. 113.

31 One *braccio fiorentino* is about 58.3 cm.

32 Chambers 1970, pp. 94–5.

33 See Ames-Lewis 1984, pp. 44–8.

34 Musacchio 1998; Musacchio in New York 2008, pp. 154–6.

35 Musacchio 2008, p. 136.

36 Musée des Arts Décoratifs, Paris, inv. nos PE87, PE88.

37 Krohn in New York 2008, p. 64 suggests that the wedding furniture was made in the few months between the *giuramento* (betrothal) and *annellamento* (giving of rings). See also Witthoft 1982, pp. 44–5.

38 For Pierfrancesco's cassoni, see n. 30 above. On dates for his marriage, see Brown 1979, p. 86, n. 27.

39 For a possible identification of Giovanni and Ginevra's cassoni, see Baskins in Boston and Sarasota 2008–9, p. 62.

40 Hatfield 1970.

41 For other possible examples of parents giving pre-existing chests, as opposed to newly commissioned ones, to their daughters, see Musacchio 2008, p. 144.

42 'e in su uno carro il significato di Davittj, che uccise il giughante colla fronbola. E chi era per Davittj andava ritto inn altj et molto destramente in sul charro'; Hatfield 1970, pp. 112, 146 (appendix 5b).

43 Ibid., p. 113.

44 See e.g. Baskins 1993, p. 120.

45 Frick 2005, pp. 123–8.

46 Sbaraglio in Florence 2010, p. 165. For the Uffizi drawing (inv. 59F), see Degenhart and Schmitt 1968, p. 615.

47 See Polidori Calamandrei 1924, p. 84; Rainey 1985, p. 771.

48 'Una cotta d'alto basso cremisi con maniche di brochato d'oro'; see Jacomien van Dijk 2015, p. 183 (appendix 3a, 7).

49 Staderini in Florence 2010, pp. 246–51, cat. 26.

50 See, most recently, ibid. For a sceptical point of view, see Nethersole 2010.

51 Gordon 2003, p. 291; Boskovits and Brown 2003, p. 6, n. 15.

52 Barriault 1994, pp. 56–94.

53 See De Marchi in Rome 2007. Roberto Longhi (verbal opinion) described them as 'Battle of Romans and Macedons' and 'Triumph of Paulus Emilius'; Monteverdi 1960, p. 24. For a different view, see p. 42 in this publication.

54 For the emblem, see Koch 2010.

55 Florentine School, *Triumph of David*, on panel, unknown dimensions, formerly Weinberg Collection; Frankfurt 1926, no. 71. Florentine School, *Triumph of David*, on panel, 42 × 127 cm, formerly Holford Collection, Dorchester House; Benson 1927, no. 21. The ex-Holford panel borrows the triumphal cart and placement of Saul and David from the Fondazione Horne *Triumph* but relies less directly on the Pesellino prototype.

56 The fact that his cousin Pierfrancesco (married 1456) apparently owned the 'spalliera d'animali' by Pesellino suggests that this was perhaps an inherited furnishing rather than one he commissioned himself.

Pesellino's legacy

1 Filarete's *Trattato di architettura* (1460–4) is the earliest mention of Pesellino. Lamenting the dearth of good painters in Florence, Filarete described the late Pesellino as a 'great master of animals' ('grande maestro d'animali'); Finoli and Grassi 1972, pp. 264–5. Some fifteen years later, Cristoforo Landino wrote that Pesello stood above all others in the depiction of animals ('Pesello sopra gli altri valse negli animali') and that he was succeeded by Pesellino, who excelled 'in compositions of small things' ('in compositione di cose picchole excellente'); Landino 2001, vol. 1, p. 241.

2 Frey 1892a, p. 27 and Frey 1892b, pp. 100–1. In both, the lions behind a grate, a painted overdoor attributed to Pesellino ('Francesco di Pesello') in the 1492 inventory of the Palazzo Medici (see p. 21 in this publication), were ascribed to his grandfather. Both also attributed the lost spalliera with animals in the *casa vecchia* (see pp. 25–6 in this publication) as well as the Pistoia Altarpiece (cat. 8) to Pesello. Billi lists no works by Pesellino, simply stating that he was particularly talented as a painter of 'small things'. The Anonimo Magliabechiano, who supplied each painter with a short biography, added to Billi's information that Pesellino painted the predella of the Novitiate Altarpiece (perhaps information garnered from Albertini's *Memoriale* of 1510; see de Boer 2010, pp. 98, 171–2), as well as attributing the Pistoia Altarpiece to both grandfather and grandson in their respective entries.

3 'Costui, se più tempo viveva, per quello che si conosce, arebbe fatto molto più ch'egli non fece, perché era studioso nell'arte né mai restava né dì né notte di disegnare'; Vasari 1878–85, p. 38.

4 Hadley 1987, p. 94; Silver 2015, p. 444.

5 For a compelling examination of the technical evidence, see Gordon 2003, pp. 260–7, 273–8.

6 On obstacles they had run into previously, in part owing to the work being produced at some distance in Florence, see ibid., pp. 271–3.

7 For a discussion on contemporary understanding of style, see Sheridan 2001, pp. 9–35; see also Baxandall 1974.

8 For Domenico Veneziano, see cat. 8 and p. 29.

9 See Gordon 2003, p. 285, n. 39.

10 For the litigation between Piero di Lorenzo Pratese and Pesellino's widow, Tarsia, see ibid., pp. 273 and cat. 8 in this publication.

11 Kecks 1988; Holmes 1999, pp. 145–50; Musacchio 2000, pp. 150–2; Verdon 2014, p. 13.

12 Famous examples include the workshop of Giovanni Bellini, see Golden 2004; and of Botticelli, see O'Malley 2014.

13 Davies 1986, p. 420.

14 On the confusing nature of this moniker, see Davies 1986, p. 420; Strehlke 2004, p. 367.

15 Moniker coined by Zeri 1976, vol. 1, pp. 80–5; see also Holmes 2004.

16 Holmes 2004, p. 40 identifies 83 surviving copies of Pesellino's paintings, 79 of which are made after the three Virgin and Child prototypes.

17 Staderini in Pontassieve 2010, cat. 16, pp. 163–5. Sonnevend 2011 argued that the Esztergom version is the earliest of the two and the two panels were not made using the same cartoon.

18 Strehlke 2004, pp. 368–70.

19 Staderini in Pontassieve 2010, cat. 16, pp. 162–5 identifies these works as among the more accomplished of the Lippi Pesellino imitators, indicating probable association with the workshop of Pesellino himself.

20 This proposition is also made by Strehlke 2004, p. 367 and Staderini in Pontassieve 2010, cat. 17, p. 169.

21 *Triumph of David*, Christie's, London, 8 December 2005, lot 23; *David and Goliath*, Christie's, London, 25 January 2012, lot 2: see Cook 1906; Callmann 1974, p. 39, n. 4.

22 For other examples of cassoni depicting the story of David which rely on the model of Pesellino, see Ames-Lewis 2000, p. 191, n. 5.

23 On the Pollaiuolo brothers' Hercules paintings, see Wright 2005, pp. 81–7, 98–102.

24 Cook 1906 and Callmann 1974, pp. 44–5 understood the *testate* to be contemporaneous with the front panels but, according to the Christie's lot essay (2005), Alison Wright believed them to be later (mid-1470s).

25 On the trend for battle and triumph pairs in the final third of the fifteenth century, see Baskins 2002, p. 12.

26 For the iconography of David in the second half of the fifteenth century, see Butterfield 1997, pp. 27–31 and Radke 2003.

27 Andrea del Verrocchio, *David with the Head of Goliath* (about 1475, Museo Nazionale del Bargello, Florence, inv. 450, 451); Pollaiuolo brothers, *David with the Head of Goliath* (1465–70, Gemäldegalerie, Berlin, inv. 73A).

28 Staderini 2013, pp. 63–4 suggests that these drawings were produced by an artist in the circle of Verrocchio.

29 This drawing was attributed to Pesellino himself by Cadogan 2007 and Silver in this publication, p. 22.

30 See also the figure of Anthony Abbot in Fra Diamante's *Madonna and Child with Saints* in the Museum of Fine Arts, Budapest, which is closely derived from Pesellino's figure of the same saint in the Louvre altarpiece (fig. 13). On Fra Diamante borrowing from Pesellino, see Staderini 2013, pp. 58–9 and Fattorini 2014, pp. 374–6. On the possibility Lippi's workshop inherited works from Pesellino's workshop (including other unfinished paintings), see Staderini 2013, pp. 57–62.

Catalogue

1 The Stigmatisation of Saint Francis and The Miracle of the Black Leg

1 De Boer 2010, p. 98.

2 Cosimo's patronage of key sites across the city was likely part of his strategy to eradicate the factionalism that had led to his 1433–4 exile. On his patronage of Florentine religious institutions, see Kent 2000, pp. 64–90. A record of a 1445 dedicatory inscription on the chapel bell provides the latest possible date for the bulk of the chapel's construction; Moise 1845, p. 163. For the date and construction of the chapel, see also Caplow 1977, vol. 2, pp. 577–86; Miller 1983, pp. 181–6; Saalman 1993, pp. 224–6.

3 The novices remained separate from the rest of the community of friars as they trained in the Divine Office and learned the Franciscan way of life; see Holmes 1999, pp. 199–200.

4 Pittaluga 1949, p. 176–7 dated the altarpiece to about 1442 (together with other earlier commentators); Ruda 1993, cat. 32, pp. 414–16 suggested second half of 1440s; Holmes 1999, pp. 191–213, 1440–5; Miller 1983, pp. 180–97, about 1445–7. Staderini in Pontassieve 2010, p. 118 approximated the predella stylistically to the Boston *Triumphs*.

5 The remaining three eventually entered the Uffizi, together with Lippi's main panel and a copy of the missing two scenes. On the copy, see Dori, Dori and Seccaroni 2018, p. 21.

6 'una maravigliosissima predella di figure piccole, le quali paiono di mano di Fra Filippo', Vasari 1878–85, p. 38–9.

7 For two recent explorations of imagery of the Miracle of the Black Leg, see Cooper 2021 and Nethersole 2022.

2 King Melchior sailing to the Holy Land

1 Musée des Beaux-Arts de Strasbourg, MBA 261.

2 This later naming of the Magi was first attested in a lost Greek chronicle, probably composed in Alexandria (about 500 CE), that only survives in a Latin translation (*Excerpta Latina Barbari*); see Burgess 2013.

3 The attribution to Pesellino was first proposed in the 1950s by Frankfurter 1957, p. 52, restated by Fahy in Milan 2001, p. 74 who rightly drew a comparison with the *De Secundo Bello* manuscript Pesellino made in partnership with Zanobi Strozzi in 1447. The panel had previously been attributed to Zanobi Strozzi, Domenico di Michelino (by Berenson), Benozzo Gozzoli (Williamstown 1957) and other followers of Fra Angelico. The attribution to Pesellino was supported by De Marchi in Bentini, Cammarota and Scaglitti Kelescian 2004, pp. 220–3, no. 83 and Kanter in New York 2005b, pp. 278–83, cats. 54A and B. Di Lorenzo in Prato 2013–14, pp. 136–9, cat. 3.3, believed it to be a collaboration between Pesellino and Domenico di Michelino. De Marchi (verbal communication 2023) now believes an attribution to Domenico Michelino is more likely.

4 Di Lorenzo in Prato 2013–14, cat. 3.3, pp. 136–9. On Pesellino's collaboration with Zanobi Strozzi, see Kanter in New York 2005b, pp. 269–71.

5 On Alfonso Tacoli Canacci and his collection, see Sbaraglio in Florence 2014, pp. 211–12 and Tacoli Canacci 1790.

6 As suggested by Fahy in Milan 2001 and di Lorenzo in Prato 2013–14, p. 138.

7 Kanter's hypothesis in New York 2005b, pp. 282–3 that the panels were intended to be displayed together, inside the Palazzo Medici with the Cook tondo, is not persuasive. Strehlke in New York 2005b, pp. 206, 213, n. 42 suggested that the yellow and red of the sails – the heraldic colours of Alfonso of Aragon, King of Naples – could point to his patronage of the series, or at least be a reference to his conquest of Naples. Strehlke's hypothesis, which predates the discovery by Galli 2007, p. 26, n. 41, that the panel was in the Tacoli Canacci collection, was not sustained by di Lorenzo in Prato 2013–14, cat. 3.3, pp. 136–9.

3 Figure of a Bishop holding a Staff and a Book: Saint Augustine

1 On the uncertain identities of the saints in the Metropolitan Museum of Art panel, see Kanter in New York 2005b, p. 288; Silver in this publication, pp. 13–17.

2 Mackowsky 1898–9, pp. 83–4 and Weisbach 1901, pp. 68–9 believed the Louvre drawing to be a preparatory study for the painted panel. Berenson 1903, vol. 1, p. 55, n. 2, initially believed the Louvre drawing to be a copy after the Metropolitan figure, whom he identified as Saint Augustine. Later, Berenson 1938, vol. 2, p. 255, no. 1841A, adjusted his position and listed the Louvre drawing as preparatory. Meder 1919, p. 664 believed the drawing to be a copy after the painting. Degenhart and Schmitt 1968, p. 528, no. 528 were uncertain if the Louvre drawing was preparatory or made after the panel. Zeri 1971, p. 96 also did not commit to one position or another. Kanter in New York 2005b, cat. 56, p. 288 erred towards it being a copy after the panel.

3 Kanter in New York 2005b, p. 288.

4 The dimensions of the painted surface of the New York panel (excluding modern additions of strips of wood at each side) are 22.6 × 20.3 cm.

4 The Annunciation

1 'in compositione di cose picchole excellente'; Landino 2001, vol. 1, p. 241. The work was first attributed to Pesellino by Berenson 1905, p. 43. Technical examination and imaging show that the painting was underdrawn to a high level of detail, with many elements carefully reworked in the painting stages, an approach consistent with our knowledge of Pesellino's meticulous attention to minute detail in the design and execution of his paintings; see Battle, Gent and Waldron 2016, pp. 17–19.

2 Holmes 2013, especially pp. 80–3.

3 Christiansen in New York 2005a, p. 188.

4 Ibid.; Angelini in Bellosi 1990, pp. 125–7.

5 The blue of the sky and the columns were painted over the lilac of the walls. The columns also sit awkwardly on the orange floor. These observations, as well as the presence of apparent incisions that do not correspond with final painted elements, may indicate that both figures were initially planned to occupy a shared interior; see Battle, Gent and Waldron 2016, p. 20. Gabriel's placement in the garden and the lily brandished in front of his body, not over the shoulder, both reappear in Lippi's Medici lunette (National Gallery, London, NG666). Since both works probably date to the early 1450s, it is difficult to propose one or other as prototype, but between them these works reveal the trend towards an ever more ambitious pictorial construction in the transition of internal to external space.

6 For all technical observations in this paragraph, see Battle, Gent and Waldron 2016.

7 It is likely that at this time the edges of the panel beyond the barbe (raised lip of gesso) were painted to extend the scene across the entirety of the panels. On this and the saw marks and worm holes visible along the edges, see ibid., p. 25.

8 Cooper 2006, p. 192.

9 New York 2005a, p. 188.

5 A Miracle of Saint Sylvester

1 Weiss 1966, pp. 23, 28.

2 The truncated dragon in one Doria Pamphilj panel and the trimmed figures of Sylvester and Constantine in the other indicate that both may have been cut down slightly.

3 The Worcester panel is about 9 cm narrower than the Hermitage Saint Sylvester Enthroned and the Doria Pamphilj panels are 15 cm narrower than the left-hand Baptism panel. The Doria Pamphilj panels may have been trimmed, see n. 2 above.

4 Suggestion made by Lachi 1995, pp. 21–4. For later discussion of this theory, see Christiansen in New York 2005a, pp. 56, 64, n. 49; di Lorenzo in New York 2005a, p. 291; De Marchi in New York 2005a, pp. 88, 95, n. 85; Kanter in New York 2005b, p. 287, n. 8.

6 The Story of David and Goliath and The Triumph of David

1 See Eastlake notebooks of 1862: 1, fol. 16 (verso) and 17 (recto) and Crowe and Cavalcaselle 1864, vol. 2, pp. 366–7. For a stylistic comparison of David with the figure of Saint Mamas in the Pistoia Altarpiece, see p. 20 in this publication.

2 In addition to X-radiography and infrared reflectography, Reflectance Imaging Spectroscopy (RIS) and X-Ray Fluorescence (XRF) scanning were undertaken on the Triumph. There was some sampling and analysis to support the interpretation of results. Infrared reflectography was carried out by Rachel Billinge, who also took the photomicrographs; Nathan Daly and Marta Melchiorre Di Crescenzo collected the RIS and XRF data that she interpreted and completed with pigment analysis; the organic binding media were analysed by Eugenia Geddes da Filicaia and Nelly von Aderkas. A full account of this investigation and treatment will appear in a future National Gallery Technical Bulletin.

3 The panels were planed down on the reverse and fitted with cradles, likely in the late nineteenth century when they were for sale in Florence. These cradles have been retained following the recent treatment. It was probably at this time that they were each bisected vertically, presumably with a view to their sale as four paintings. Fortunately, they seem to have been rejoined almost immediately so there is little loss and distortion along the cuts.

4 Organic analysis of the dark paint's binding medium was not conclusive. The possibility of a selective use of oil for these passages is raised by the inclusion of a small amount of copper compounds, which could function as a siccative (drier) and here have no obvious impact on the colour.

5 For other instances of dents in the surfaces of cassoni caused by keys, see Dunkerton et al. 2021, pp. 23–4, 62, n. 28. In the recent restoration of the David panels, dark marks resulting from the old varnish have been touched out to recover the legibility of the image, but the dents have not been filled, making this part of the history of the panels easily detectable to the interested viewer. The same approach has been taken to the more disfiguring scratches. Interestingly, where areas of gilding were struck by the keys, the indentations did not retain the accumulations

of varnish and the surface skin of gold leaf remains uninterrupted. This suggests the gesso beneath was still sufficiently flexible to absorb the blows (as when tooling fresh gilding), an indication that the cassoni were used for storage purposes soon after they were made.

7 Virgin and Child

1 Holmes 2004, p. 40, identified 24 versions of the Lyon composition. See, for example, versions in National Gallery of Art, Washington DC; Walters Art Gallery, Baltimore; National Galleries of Scotland, Edinburgh; Victoria and Albert Museum, London; National Gallery, London; Musée du Petit Palais, Avignon.

2 See Hudson 2008, pp. 180–1 and Llewellyn in London 2023, pp. 160–1.

3 The child's halo appears to have been entirely regilded, the Virgin's retains its original gilding.

8 The Pistoia Altarpiece

1 Bacci 1944, p. 113.

2 On hiring Maso di Bartolomeo to make a candelabrum for Pistoia Cathedral, see Donati in Prato 2013–14, p. 192. For possible Prato commissions, see Hudson 2008, pp. 170, 175, n. 48; Holmes 1999, p. 155.

3 Even 1984, p. 177.

4 Bacci 1944, p. 123, doc. 6. The panel for this altarpiece was supplied by another Medici associate, Antonio Manetti, the woodworker and architect whom Giovanni di Cosimo de' Medici consulted about the construction of his new villa at Fiesole; Lillie in Beyer and Boucher 1993, pp. 189–205.

5 'fogli per fare scritture e per li disegni feci fare' ('paper for writing and for the drawings he [Prete Pero] had had made'); Bacci 1944, p. 119, doc. 2. Prete Pero also claimed expenses for his travel to Florence on the same day, 17 September 1455.

6 O'Malley 2005, p. 201.

7 Bacci 1944, p. 115 observed that Prete Pero, who had argued for the inclusion of Saint Mamas in this altarpiece, was in disgrace before the commission was given to Lippi; Gordon 2003, pp. 273–4 has used Mamas, even if not entirely finished by Pesellino, for attributing to him the angels, Saint James, the feet of God the Father and for the laying in of the background and foreground landscapes.

8 Roy and Gordon 2001, pp. 14–15, n. 31 and summarised by Gordon 2003, p. 74.

9 Bacci 1944, p. 121, doc. 3. The only other individual identified in the documents as a qualified judge was Piero di Cosimo de' Medici, ibid., p. 123, doc. 6.

10 Krohn 2003; Thomas 1997, pp. 193–4. Eisler 1984 attributed the window to Domenico Veneziano and his workshop.

11 Bacci 1944, pp. 135–6, doc. 1. The altarpiece was in Florence so the priests in Pistoia had to pay shipping costs to Prato, where Lippi worked, and they incurred costs for travel to Florence and Prato.

12 Gordon 2003, p. 275.

13 Ibid., p. 284, n. 11; Silver 2012, p. 115.

BIBLIOGRAPHY

AMES-LEWIS 1979
F. Ames-Lewis, 'Early Medicean Devices', *Journal of the Warburg and Courtauld Institutes*, 42 (1979), pp. 122–43

AMES-LEWIS 1984
F. Ames-Lewis, *The Library and Manuscripts of Piero di Cosimo de' Medici*, New York and London 1984

AMES-LEWIS 2000
F. Ames-Lewis, 'Francesco Pesellino's "Story of David" Panels in the National Gallery, London', *Biuletyn historii sztuki*, 62 (2000), pp. 189–203

ASF 1433
Archivio di Stato di Firenze, Florence, *Portata al Catasto*, 1433, Quartiere S. Spirito, Gonfalone Drago 442

BACCI 1944
P. Bacci, *Documenti e commenti per la storia dell'arte con numerose illustrazioni*, Florence 1944

BAMBACH 1999
C. Bambach, *Drawing and Painting in the Italian Renaissance Workshop: Theory and Practice, 1300–1600*, Cambridge 1999

BARRIAULT 1994
A. Barriault, *Spalliera Paintings of Renaissance Tuscany: Fables of Poets for Patrician Homes*, University Park, PA 1994

BASKINS 1993
C.L. Baskins, 'Donatello's Bronze "David": Grillanda, Goliath, Groom?', *Studies in Iconography*, 15 (1993), pp. 113–34

BASKINS 2002
C.L. Baskins, '(In)Famous Men: The Continence of Scipio and Formations of Masculinity in Fifteenth-Century Tuscan Domestic Painting', *Studies in Iconography*, 23 (2002), pp. 109–36

BATTLE, GENT AND WALDRON 2016
E. Battle, A. Gent and K. Waldron, Unpublished technical study by students in the Department of Conservation, Courtauld Institute of Art, London 2016

BAXANDALL 1974
M. Baxandall, 'Alberti and Cristoforo Landino: The Practical Criticism of Painting', in *Convegno internazionale indetto nel V centenario di Leon Battista Alberti*, Rome 1974, pp. 143–54

BELLOSI 1990
L. Bellosi (ed.), *Pittura di luce: Giovanni di Francesco e l'arte fiorentina di metà Quattrocento*, Milan 1990

BENASSAI ET AL. 2014
P. Benassai et al. (eds), *Officina pratese: tecnica, stile, storia*, Florence 2014

BENSON 1927
R. Benson, *The Holford Collection: Dorchester House*, Oxford 1927

BENTINI, CAMMAROTA AND SCAGLITTI KELESCIAN 2004
J. Bentini, G.P. Cammarota, D. Scaglitti Kelescian (eds), *Pinacoteca nazionale di Bologna: catalogo generale. 1. Dal Duecento a Francesco Francia*, Venice 2004

BERENSON 1903
B. Berenson, *The Drawings of the Florentine Painters*, 2 vols, London 1903

BERENSON 1905
B. Berenson, 'Una Annunciazione del Pesellino', *Rassegna d'arte*, 5 (March 1905), pp. 42–3

BERENSON 1938
B. Berenson, *The Drawings of the Florentine Painters*, 2 vols, enlarged edn, Chicago 1938

BERENSON 1963
B. Berenson, *Italian Pictures of the Renaissance: Florentine School*, 2 vols, London 1963

BEYER AND BOUCHER 1993
A. Beyer and B. Boucher (eds), *Piero de' Medici 'il Gottoso' (1416–1469): Kunst im Dienste der Mediceer/Art in the Service of the Medici*, Berlin 1993

BIBBY 2007/8
S. Bibby, 'Changing Perspectives: The Florentine Histories of Uccello's *Battle of San Romano* Panels', *Object*, 10 (2007/8), pp. 5–24

BIETTI 2018
M. Bietti (ed.), *Intorno all'Annunciazione Martelli di Filippo Lippi: riflessioni dopo il restauro*, Florence 2018

BORSI AND BORSI 1992
F. Borsi and S. Borsi, *Paolo Uccello*, Milan 1992

BOSKOVITS AND BROWN 2003
M. Boskovits and D.A. Brown (eds), *Italian Paintings of the Fifteenth Century: The Systematic Catalogue of the National Gallery of Art, Washington, D.C.*, New York 2003

BOSTON AND SARASOTA 2008–9
C.L. Baskins (ed.), *The Triumph of Marriage: Painted Cassoni of the Renaissance*, exh. cat., Isabella Stewart Gardner Museum, Boston 2008–9; John and Mable Ringling Museum of Art, Sarasota, FL 2009

BROWN 1979
A. Brown, 'Pierfrancesco de' Medici, 1430–1476: A Radical Alternative to Elder Medicean Supremacy?', *Journal of the Warburg and Courtauld Institutes*, 42 (1979), pp. 81–103

BULST 1970
W. Bulst, 'Die ursprüngliche innere Aufteilung des Palazzo Medici in Florenz', *Mitteilungen des Kunsthistorischen Institutes in Florenz*, 14, no. 4 (December 1970), pp. 369–92

BULST 1990
W. Bulst, 'Uso e trasformazione del Palazzo mediceo fino ai Riccardi', in G. Cherubini and G. Fanelli (eds), *Il Palazzo Medici Riccardi di Firenze*, Florence 1990, pp. 98–129

BURGESS 2013
R.W. Burgess, 'The Date, Purpose, and Historical Context of the Original Greek and the Latin Translation of the so-called *Excerpta Latina Barbari*', *Traditio*, 68 (2013), pp. 1–56

BURKE 2004
J. Burke, *Changing Patrons: Social Identity and the Visual Arts in Renaissance Florence*, University Park, PA 2004

BUTTERFIELD 1995
A. Butterfield, 'New Evidence for the Iconography of David in Quattrocento Florence', *I Tatti Studies in the Italian Renaissance*, 6 (1995), pp. 115–33

BUTTERFIELD 1997
A. Butterfield, *The Sculptures of Andrea del Verrocchio*, New Haven and London 1997

CADOGAN 2007
J.K. Cadogan, 'Notes on a drawing by Pesellino', *The Burlington Magazine*, 149, no. 1256 (November 2007), pp. 767–71

CAGLIOTI 2001
F. Caglioti, 'Nouveautés sur la "Bataille de San Romano" de Paolo Uccello', *Revue du Louvre*, 51, no. 4 (2001), pp. 37–54

CALLMANN 1974
E. Callmann, *Apollonio di Giovanni*, Oxford 1974

CALLMANN 1999
E. Callmann, 'William Blundell Spence and the Transformation of Renaissance Cassoni', *The Burlington Magazine*, 141, no. 1155 (June 1999), pp. 338–48

CAPLOW 1977
H.M. Caplow, *Michelozzo*, 2 vols, London and New York 1977

CASTELLANI 1995
F. di M. Castellani, *Ricordanze II: Quaternuccio e giornale B (1459–1485)*, ed. G. Ciappelli, Florence 1995

CATALUCCI 2014
V. Catalucci, 'La famiglia Del Nero di Firenze: proprietà, patrimonio e collezioni; il palazzo Del Nero (oggi Torrigiani in piazza dei Mozzi), 2a parte', *Studi di Storia dell'Arte*, 25 (2014), pp. 109–44

CHAMBERS 1970
D.S. Chambers, *Patrons and Artists in the Italian Renaissance*, London 1970

COOK 1906
H. Cook, 'The New Haven Pollaiuolo', *The Burlington Magazine*, 9 (1906), pp. 52–3

COOPER 2006
D. Cooper, 'Devotion', in M. Ajmar-Wollheim and F. Dennis (eds), *At Home in Renaissance Italy*, exh. cat., Victoria and Albert Museum, London 2006, pp. 190–203

COOPER 2021
C.M. Cooper, 'The Miracle of the Black Leg: Medical Knowledge, Race and Territorialization', in S. Oldenburg and K.M.S. Bezio (eds), *Religion and the Medieval and Early Modern Global Marketplace*, New York 2021

COURTAULD INSTITUTE OF ART 1967
The Gambier-Parry Collection: Provisional Catalogue, London 1967

CROWE AND CAVALCASELLE 1864
J.A. Crowe and G.B. Cavalcaselle, *A New History of Painting in Italy from the Second to the Sixteenth Century*, 3 vols, London 1864

DAVIES 1961
M. Davies, *National Gallery Catalogues: The Earlier Italian Schools*, London 1951 (2nd edn 1961)

DAVIES 1974
M. Davies, 'Italian School', in *European Paintings in the Collection of the Worcester Art Museum*, 2 vols, Worcester, MA 1974, vol. 1, pp. 307–493

DAVIES 1986
M. Davies, *National Gallery Catalogues: The Earlier Italian Schools*, London 1986

DE BOER 2010
W.H. de Boer (ed.), *Memorial of Many Statues and Paintings in the Illustrious City of Florence by Francesco Albertini: A Booklet Devoted to Florentine Art*, Florence 2010

DEGENHART AND SCHMITT 1968
B. Degenhart and A. Schmitt, *Corpus der italienischen Zeichnungen, 1300–1450*, 2, part 1: *Süd- und Mittelitalien*, Berlin 1968

DORI, DORI AND SECCARONI 2018
A. Dori, L. Dori and C. Seccaroni, 'Nota tecnica sulla "Pala del Noviziato" di Filippo Lippi', *Bollettino ICR/ Istituto Superiore per la Conservazione ed il Restauro*, n.s. 36 (2018), pp. 13–24

DUNKERTON ET AL. 2021
J. Dunkerton, C. Higgitt, M. Melchiorre Di Crescenzo and R. Billinge, 'A Case of Collaboration: The *Adoration of the Kings* by Botticelli and Filippino Lippi', *National Gallery Technical Bulletin*, 41 (2021), pp. 18–67

EISLER 1984
C. Eisler, 'A Window on Domenico Veneziano at Santa Croce', in M. Natale (ed.), *Scritti di storia dell'arte in onore di Federico Zeri*, 2 vols, Milan 1984, vol. 1, pp. 130–3

EVEN 1984
Y. Even, 'Artistic Collaboration in Florentine Workshops: Quattrocento', PhD dissertation, Columbia University 1984

FATTORINI 2014
G. Fattorini, 'Fra Diamante a Prato, al fianco di Filippo Lippi: un bilancio degli studi Officina pratese', in Benassai et al. 2014, pp. 367–85

FINOLI AND GRASSI 1972
A.M. Finoli and L. Grassi (eds), *Antonio Averlino detto Il Filarete: Trattato di architettura*, Milan 1972

FLORENCE 2005
M. Boskovits with D. Parenti (eds), *Da Bernardo Daddi al Beato Angelico a Botticelli: dipinti fiorentini del Lindenau-Museum di Altenburg*, exh. cat., Museo di San Marco, Florence 2005

FLORENCE 2010
C. Paolini and D. Parenti (eds), *Virtù d'amore: pittura nunziale nel Quattrocento fiorentino*, exh. cat., Galleria dell'Accademia, Florence 2010

FLORENCE 2014
L. Sbaraglio, 'Alfonso Tacoli Canacci', in *La fortuna dei primitivi: tesori d'arte dalle collezioni italiane fra Sette e Ottocento*, ed. A. Tartuferi and G. Tormen, exh. cat., Galleria dell'Accademia, Florence 2014, pp. 210–15

FRANKFURT 1926
O. Götz, G. Swarzenski and A. Wolters, *Ausstellung von Meisterwerken alter Meister aus Privatbesitz: Sommer 1925*, exh. cat., Städelsches Kunstinstitut, Frankfurt 1926

FRANKFURTER 1957
A. Frankfurter, 'Now the Old Masters at Williamstown', *Art News*, 56 (December 1957), pp. 29–30, 51–3

FREY 1892a
C. Frey (ed.), *Il libro di Antonio Billi esistente in due copie nella Biblioteca Nazionale di Firenze* [1481–1530], Berlin 1892

FREY 1892b
C. Frey (ed.), *Il Codice Magliabechiano cl. XVII* [about 1537–42], Berlin 1892

FRICK 2005
C.C. Frick, *Dressing Renaissance Florence: Families, Fortunes, and Fine Clothing*, Baltimore, MD 2005

FUSCO AND CORTI 2006
L. Fusco and G. Corti, *Lorenzo de' Medici, Collector and Antiquarian*, Cambridge and New York 2006

GALLI 2007
A. Galli, 'Tavole toscane del Tre e Quattrocento nella collezione di Alfonso Tacoli Canacci', in N. Baldini (ed.), *Invisibile agli occhi*, Florence 2007, pp. 13–28

GERULLI 1933
M.L. Gerulli, 'Francesco Pesellino', MA thesis, Università degli Studi di Firenze, Florence 1933

GOLDEN 2004
A. Golden, 'Creating and Re-creating: The Practice of Replication in Giovanni Bellini's Workshop', in R. Kasl (ed.), *Giovanni Bellini and the Art of Devotion*, Indianapolis 2004, pp. 91–3

GORDON 2003
D. Gordon, *The Fifteenth Century: Italian Paintings*, London 2003

GRONAU 1938
G. Gronau, 'In margine a Francesco Pesellino', *Rivista d'arte*, 20 (1938), pp. 123–46

GROOM 2018
A. Groom, *Exotic Animals in the Art and Culture of the Medici Court in Florence*, Leiden 2018

HADLEY 1987
R. van N. Hadley (ed. and annot.), *The Letters of Bernard Berenson and Isabella Stewart Gardner, 1887–1924, with Correspondence by Mary Berenson*, Boston 1987

HATFIELD 1970
R. Hatfield, 'Some Unknown Descriptions of the Medici Palace in 1459', *The Art Bulletin*, 52, no. 3 (September 1970), pp. 232–49

HENDY 1931
P. Hendy, *Isabella Stewart Gardner Museum: Catalogue of the Exhibited Paintings and Drawings*, Boston 1931

HOLMES 1999
M. Holmes, *Fra Filippo Lippi: The Carmelite Painter*, New Haven and London 1999

HOLMES 2004
M. Holmes, 'Copying Practices and Marketing Strategies in a Fifteenth-Century Florentine Painter's Workshop', in S.J. Campbell and S.J. Milner (eds), *Artistic Exchange and Cultural Translation in the Italian Renaissance City*, Cambridge 2004, pp. 38–74

HOLMES 2013
M. Holmes, *The Miraculous Image in Renaissance Florence*, New Haven and London 2013

HORNE [about 1907–]
H.P. Horne, Manuscript for a book on Pesellino, Fondazione Horne, Florence, Inv. 2587/8, segn. G.XI.1

HUDSON 2008
H. Hudson, *Paolo Uccello: Artist of the Florentine Renaissance Republic*, Saarbrücken 2008

JACOBSEN 2001
W. Jacobsen, *Die Maler von Florenz: Zu Beginn der Renaissance*, Munich 2001

JACOMIEN VAN DIJK 2015
S. Jacomien van Dijk, 'Beauty adorns Virtue: Dress in Portraits of Women by Leonardo da Vinci', PhD dissertation, Leiden University 2015

KECKS 1988
R.G. Kecks, *Madonna und Kind: Das häusliche Andachtsbild im Florenz des 15. Jahrhunderts*, Frankfurt 1988

KENT 2000
D.V. Kent, *Cosimo de' Medici and the Florentine Renaissance: The Patron's Oeuvre*, New Haven and London 2000

KOCH 2010
L.A. Koch, 'Power, Prophecy, and Dynastic Succession in Early Medici Florence: The Falcon Impresa of Piero di Cosimo de' Medici', *Zeitschrift für Kunstgeschichte*, 73, no. 4 (2010), pp. 507–38

KRAUTHEIMER 1956
R. Krautheimer, *Lorenzo Ghiberti*, Princeton 1956

KROHN 2003
D. Krohn, 'Taking Stock: Evaluation of Works of Art in Renaissance Italy', in M. Fantoni, L. Matthew and S. Matthews Grieco (eds), *The Art Market in Italy (15th–17th Centuries)*, Ferrara 2003, pp. 203–11

LACHI 1995
C. Lachi, *Il Maestro della Natività di Castello*, Florence 1995

LACLOTTE AND MOGNETTI 1977
M. Laclotte and E. Mognetti, *Avignon – Musée du Petit Palais – Peinture italienne*, Paris 1977

LACLOTTE 1978
M. Laclotte, '"Une chasse" du Quattrocento florentin', *Revue de l'art*, 40–1 (1978), pp. 65–70

LANDINO 2001
C. Landino, *Comento sopra la Comedia [di Dante Alighieri]*, ed. P. Procaccioli, 4 vols, Rome 2001

LILLIE 2007
A. Lillie, 'Fiesole: *Locus Amoenus* or Penitential Landscape', *I Tatti Studies: Essays in the Renaissance*, 11 (2007), pp. 11–55

LONDON 2009
C. Campbell, *Love and Marriage in Renaissance Florence: The Courtauld Wedding Chests*, exh. cat., Courtauld Gallery, London 2009

LONDON 2023
P. Motture (ed.), *Donatello: Sculpting the Renaissance*, exh. cat., Victoria and Albert Museum, London 2023

LURATI 2021
P. Lurati, *'Animali maravigliosi'. Orientalismo e animali esotici a Firenze in epoca tardogotica e rinascimentale: conoscenza, immaginario, simbologia*, Bellizona 2021

MACKOWSKY 1898-9
H. Mackowsky, 'Die Verkündigung und die Verlobung der Heiligen Katharina von Francesco Pesellino', *Zeitschrift für bildende Kunst*, n.s., 10 (1898–9), pp. 83–4

MEDER 1919
J. Meder, *Die Handzeichnung: Ihre Technik und Entwicklung*, Vienna 1919

MILAN 2001
A. di Lorenzo (ed.), *Omaggio a Beato Angelico*, exh. cat., Milan 2001

MILANESI 1860
G. Milanesi, 'Portata di Giuliano d'Arrigo detto Pesello, al Catasto del 1427', *Giornale storico degli archivi toscani*, 4, no. 3 (Autumn 1860), pp. 189–91, 205–7

MILLER 1983
J.I. Miller, 'Major Florentine Altarpieces from 1430 to 1450', PhD dissertation, Columbia University 1983

MOISE 1845
F. Moise, *Santa Croce di Firenze: illustrazione storico-artistica*, Florence 1845

MOLHO 1994
A. Molho, *Marriage Alliance in Late Medieval Florence*, Cambridge, MA 1994

MONTEVERDI 1960
M. Monteverdi, *Antologia di testori pittorici italiani dal XIV al XVIII secolo*, Milan 1960

MUSACCHIO 1998
J.M. Musacchio, 'The Medici-Tornabuoni "Desco da Parto" in Context', *Metropolitan Museum Journal*, 33 (1998), pp. 137–51

MUSACCHIO 1999
J.M. Musacchio, *The Art and Ritual of Childbirth in Renaissance Italy*, New Haven and London 1999

MUSACCHIO 2000
J.M. Musacchio, 'The Madonna and Child, a Host of Saints, and Domestic Devotion in Renaissance Florence', in G. Neher and R. Shepherd (eds), *Revaluing Renaissance Art*, Aldershot 2000, pp. 147–64

MUSACCHIO 2003
J.M. Musacchio, 'The Medici Sale of 1495 and the Second-Hand Market for Domestic Goods in Florence', in S.F. Matthews Grieco et al., *The Art Market in Italy*, Ferrara 2003, pp. 313–23

MUSACCHIO 2008
J.M. Musacchio, *Art, Marriage, and Family in the Florentine Renaissance Palace*, New Haven and London, 2008

NETHERSOLE 2010
S. Nethersole, 'Review of *Virtù d'Amore*', *The Burlington Magazine*, 152 (September 2010), p. 638

NETHERSOLE 2022
S. Nethersole, 'Fra Angelico's *The Miracle of the Black Leg*: Skin Colour and the Perception of Ethiopians in Florence before 1450', *Art History*, 45, no. 2 (April 2022), pp. 251–78

NEW YORK 2005a
K. Christiansen (ed.), *From Fra Filippo Lippi to Piero della Francesca: Fra Carnevale and the Making of a Renaissance Master*, exh. cat., The Metropolitan Museum of Art, New York 2005

NEW YORK 2005b
L. Kanter et al., *Fra Angelico*, exh. cat., The Metropolitan Museum of Art, New York 2005

NEW YORK 2008
A. Bayer (ed.), *Art and Love in Renaissance Italy*, exh. cat., The Metropolitan Museum of Art, New York 2008

O'MALLEY 2005
M. O'Malley, *The Business of Art: Contracts and the Commissioning Process in Renaissance Italy*, New Haven and London 2005

O'MALLEY 2014
M. O'Malley, 'Quality Choices in the Production of Renaissance Art: Botticelli and Demand', *Renaissance Studies*, 28, no. 1 (February 2014), pp. 4–32

OSTOYA 1884
G. Ostoya, *Les Anciens maîtres et leurs oeuvres à Florence: guide artistique*, Florence 1884

PARIS 1952
Dessins florentins du Trecento et du Quattrocento, Musée du Louvre, Paris 1952

PITTALUGA 1949
M. Pittaluga, *Filippo Lippi*, Florence 1949

POLIDORI CALAMANDREI 1924
E. Polidori Calamandrei, *Le vesti delle donne fiorentine nel Quattrocento*, Florence 1924

PONTASSIEVE 2010
A. Labriola (ed.), *Beato Angelico a Pontassieve: dipinti e sculture del Rinascimento fiorentino*, exh. cat., Palazzo Municipale, Pontassieve, published Florence 2010

PRATO 2013–14
A. De Marchi and C.G. Mavarelli (eds), *Da Donatello a Lippi*, exh. cat., Museo di Palazzo Pretorio, Prato 2013–14, published Milan 2013

PROCACCI 1960
U. Procacci, 'Di Jacopo di Antonio e delle compagnie di pittori del corso degli Adimari nel secolo XV', *Rivista d'arte*, 35 (1960), pp. 3–70

RADKE 2003
G.M. Radke, 'Verrocchio and the Image of the Youthful David in Florentine art', in G.M. Radke, B. Paolozzi Strozzi and M.G. Vaccari (eds), *Verrocchio's David Restored: A Renaissance Bronze from the National Museum of the Bargello, Florence*, Atlanta and Florence 2003, pp. 35–53

RAINEY 1985
R.E. Rainey, 'Sumptuary Legislation in Renaissance Florence', PhD dissertation, Columbia University 1985

ROME 2007
A. de Marchi, 'Battles', in A.S. Sonino and M. Lupo (eds), *Fascino del bello: opera d'arte dalla collezione Terruzzi*, exh. cat., Museo Centrale del Risorgimento, Rome 2007, p. 45

ROY AND GORDON 2001
A. Roy and D. Gordon, 'Uccello's *Battle of San Romano*', *National Gallery Technical Bulletin*, 22 (2001), pp. 4–17

RUBIN 1995
P.L. Rubin, *Giorgio Vasari: Art and History*, New Haven and London 1995

RUDA 1993
J. Ruda, *Fra Filippo Lippi: Life and Work with a Complete Catalogue*, London 1993

SAALMAN 1993
H. Saalman, *Filippo Brunelleschi: The Buildings*, London 1993

SANTI 1976
B. Santi, *Neri di Bicci: le ricordanze 10 marzo 1453–24 aprile 1475*, Pisa 1976

SCHUBRING 1915
P. Schubring, *Cassoni: Truhen und Truhenbilder der italienischen Frührenaissance. Ein Beitrag zur Profanmalerei im Quattrocento*, 2 vols, Leipzig 1915

SHAPLEY 1979
F.R. Shapley, *Catalogue of Italian Paintings*, 2 vols, National Gallery of Art, Washington, DC 1979

SHEARMAN 1983
J. Shearman, *The Early Italian Pictures in the Collection of Her Majesty the Queen*, Cambridge 1983

SHERIDAN 2001
V.A. Sheridan, 'Inventing Pesellino: Biography, Language and Style in Art History', MA thesis, University of California, Davis, 2001

SILVER 2012
N. Silver, 'Francesco Pesellino and the Artistic Identity of a Renaissance Painter', PhD dissertation, University of London 2012

SILVER 2015
N. Silver, 'Creating a Renaissance Painter: Pesellino, Connoisseurship, and the *Romantik*', *I Tatti Studies in the Italian Renaissance*, 18, no. 2 (2015), pp. 429–67

SILVER 2019
N. Silver, '"Among the most beautiful works he made": Botticelli's *spalliera* Paintings', in *Botticelli: Heroines and Heroes*, ed. N. Silver, exh. cat., Isabella Stewart Gardner Museum, Boston 2019, pp. 32–55

SONNEVEND 2011
M. Sonnevend, 'Pesellino esztergomi Madonnája: Adalékok egy népszerű kompozíció eredetéhez', *Művészettörténeti Értesítő*, 60, no. 1 (2011), pp. 63–73

SPALLANZANI AND BERTELÀ 1992
M. Spallanzani and G.G. Bertelà (eds), *Libro d'inventario dei beni di Lorenzo il Magnifico*, Florence 1992

SPENCER 1965
J. Spencer (ed. and trans.), *Filarete's Treatise on Architecture*, 2 vols, New Haven, CT 1965

SPENCER 1991
J. Spencer, *Andrea del Castagno and his Patrons*, Durham, NC 1991

STADERINI 2013
A. Staderini, 'La pala della Trinità di Pistoia di Francesco di Stefano, detto il Pesellino', in *Il Museo e la città: vicende artistiche pistoiesi del Quattrocento*, Pistoia 2013, pp. 39–65

STAPLEFORD 2013
R. Stapleford, *Lorenzo de' Medici at Home: The Inventory of the Palazzo Medici in 1492*, University Park, PA 2013

STREHLKE 2004
C.B. Strehlke, *Italian Paintings, 1250–1450, in the John G. Johnson Collection and the Philadelphia Museum of Art*, University Park, PA 2004

TACOLI CANACCI 1790
A. Tacoli Canacci, *Catalogo ragionato dei pittori della Scuola Toscana*, Florence 1790

THIÉBAUT 2007
D. Thiébaut, 'XIIIe-XVe siècle', in E. Foucart-Walter (ed.), *Catalogue des peintures italiennes du musée du Louvre*, Paris 2007, pp. 13–60

THOMAS 1997
A. Thomas, *The Painter's Practice in Renaissance Tuscany*, Cambridge 1997

VALAGUSSA 2018
G. Valagussa (ed.), *Accademia Carrara, Bergamo: dipinti italiani del Trecento e del Quattrocento. Catalogo completo*, Milan 2018

VASARI 1878–85
G. Vasari, *Le vite de' più eccellenti pittori, scultori ed architettori*, ed. G. Milanesi, 5 vols, Florence 1878–85 (reprint 1906), vol. 3

VENTURINI 1994
L. Venturini, *Francesco Botticini*, Florence 1994

VERDON 2014
T. Verdon (ed.), *Picturing Mary: Woman, Mother, Idea*, London 2014

WEISBACH 1901
W. Weisbach, *Francesco Pesellino und die Romantik der Renaissance*, Berlin 1901

WEISS 1966
R. Weiss, *Pisanello's Medallion of the Emperor John VIII Palaeologus*, Oxford 1966

WILLIAMSTOWN 1957
Exhibit Eight: 15th and 16th Century Paintings, exh. cat., Sterling and Francine Clark Art Institute, Williamstown, MA 1957

WITTHOFT 1982
B. Witthoft, 'Marriage Rituals and Marriage Chests in Quattrocento Florence', *Artibus et Historiae*, 3, no. 5 (1982), pp. 43–59

WRIGHT 1993
A. Wright, 'Piero de' Medici and the Pollaiuolo', in Beyer and Boucher 1993, pp. 129–49

WRIGHT 2005
A. Wright, *The Pollaiuolo Brothers: The Arts of Florence and Rome*, New Haven 2005

ZERI 1971
F. Zeri, *Italian Paintings: Florentine School*, New York 1971

ZERI 1976
F. Zeri, *Italian Paintings in the Walters Art Gallery*, 2 vols, Baltimore, MD 1976

ZLAMALIK 1982
V. Zlamalik, *Strossmayerova galerija starih majstora Jugoslavenske akademije znanosti i umjetnosti*, Zagreb 1982

LENDERS

LONDON
The Courtauld (Samuel Courtauld Trust)
His Majesty King Charles III

LYON
Musée des Beaux-Arts

PARIS
Musée du Louvre

WILLIAMSTOWN, MA
Clark Art Institute

WORCESTER, MA
Worcester Art Museum

ACKNOWLEDGEMENTS

THE first painting by Pesellino to arrive at Trafalgar Square was the central image of the Trinity from the Pistoia Altarpiece. Its acquisition by the National Gallery's first director, Charles Eastlake, in 1863 was followed by the altarpiece's incremental reunification during the 1920s and 30s. In 2000 the Gallery cemented its status as a Pesellino stronghold with the purchase of the remarkable *Stories of David*.

Given these exceptional holdings, it seems fitting that the Gallery should stage the first ever exhibition dedicated to Pesellino's short but impressive career. The impetus for doing so now was the two-year conservation treatment of the David panels, which offered an opportunity to re-evaluate this rare painter's technical and creative abilities. I wish first to express my heartfelt thanks to Jill Dunkerton, who undertook this restoration. Her profound engagement with these works is evident in the results of the treatment, but I have also profited from her insight at every stage of the project. Her contribution to this catalogue goes well beyond the important technical essay she has authored; our countless discussions inform nearly every page. We have also benefited immensely from the expertise of Rachel Billinge, Marta Melchiorre Di Crescenzo and Eugenia Geddes da Filicaia, whose findings have shed new light on Pesellino's mastery. From the project's inception, I have received the encouragement of Nat Silver, who generously shared his specialist knowledge of Pesellino during our many exchanges. His scholarship has enriched this catalogue and I am most grateful for his collaboration.

I wish to heartily thank our lenders and the army of people at each museum who have made the loans achievable. My curatorial counterparts, all of whom were quick to support the undertaking, have patiently answered a barrage of questions in the months since. Special thanks to Rita Albertson, Sébastien Allard, Esther Bell, Thomas Bohl, Dominique Cordellier, Xavier Salmon, Karen Serres, Ludmila Virassamynaïken, Claire Whitner and the Royal Collection team, who have facilitated the loan of Pesellino to our walls for over a century.

I am heavily indebted to Dillian Gordon and Patricia Rubin, who with characteristic insight and rigour were kind enough to read drafts of the catalogue essays, greatly improving them in the process. I have also benefited from stimulating and enlightening discussions with Andrea De Marchi, Stephan Wolohojian and Alison Wright. Other colleagues who have assisted my research are Maria Elena De Luca, Andrea and Lucia Dori, Fabio Gaffo, Dominique Jacquot, Daniela Parenti and Ilaria Rizzitelli. To each, my wholehearted thanks.

I am immensely grateful to Flora Allen, who with supreme command, perceptiveness and good humour has seen the catalogue into being. My thanks also to Laura Lappin for her ever calm oversight, Raymonde Watkins for her sensitive design, Katharine Ridler for her copy edits, and to Suzanne Bosman and Jane Hyne for their tireless work on the images. With an attention to detail worthy of this painter, the exhibition came together under the expert aegis of Gemma Hollington and was designed by Sophie Ballinger and Aaron Jones. Minnie Scott provided invaluable editing on the gallery texts. The exhibition was installed with masterful care by the Gallery's Art Handling team. I warmly thank them all.

I am very grateful to Gabriele Finaldi and Jane Knowles for enthusiastically agreeing it was high time to give Pesellino his day in the sun and for their guidance as the exhibition took shape. Esteemed colleagues in the Gallery's curatorial department have offered discerning criticism and practical help. My thanks to Caroline Campbell, Julie Firth, Christine Riding, Letizia Treves, Matthias Wivel and, especially, Charlotte Wytema, who meticulously read catalogue drafts and Emma Capron, who, among much else, brilliantly oversaw the exhibition's installation.

Focused and free to visit, exhibitions such as this would not be possible without the extraordinary generosity of our funders and I extend my sincere thanks to each of them. I would also like to thank colleagues across the Gallery for their help in many forms: Morag Barnes, Hugo Brown, Andrew Bruce, Catherine Heath, Sunnifa Hope, Larry Keith, Jeanne Kenyon, Beks Leary, Britta New, Belinda Phillpot, Lucy Purcell, Emily Redfield Chaplin, Alessandro Sorenti, Esmee Wright and Ellie Wyant.

In a year of several milestones, the pages of this catalogue came together over the months that we awaited the arrival of our daughter. My final thanks go to Filippo Buti for his indefatigable patience, humour and loving support.

Laura Llewellyn

PICTURE CREDITS

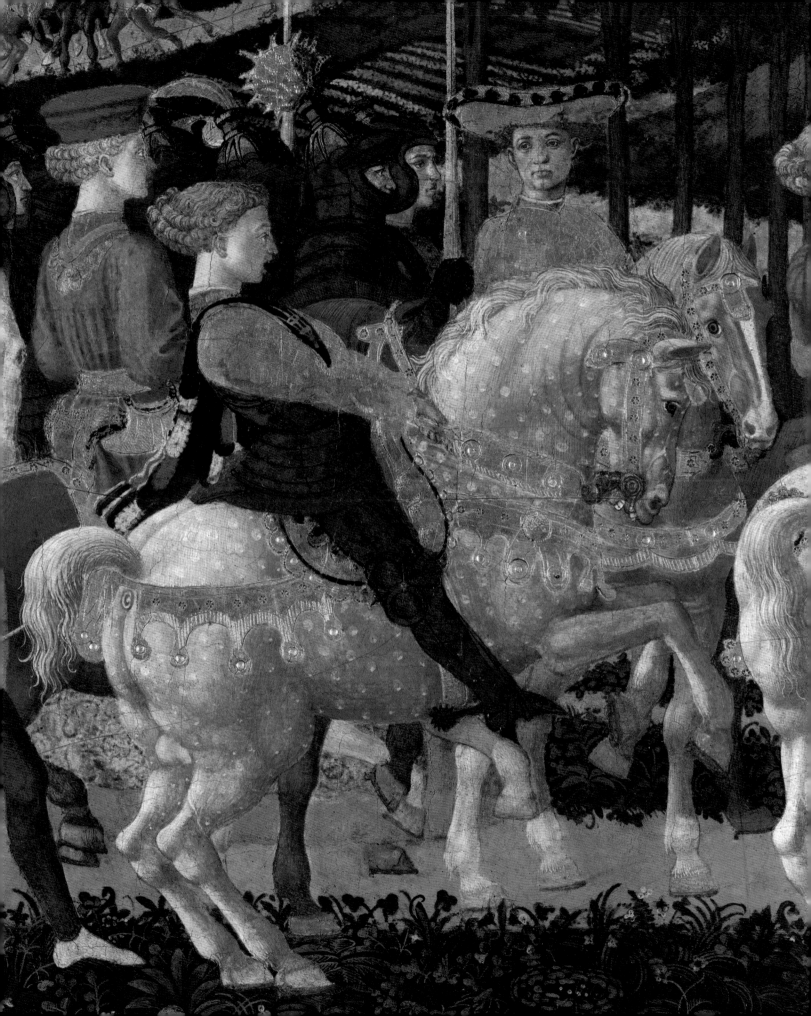

Published to accompany the exhibition
Pesellino: A Renaissance Master Revealed
The National Gallery, London,
7 December 2023–10 March 2024

Exhibition supported by

The H J Hyams Exhibition Programme
Supported by The Capricorn Foundation

Additional support provided by

The Vaseppi Trust
Mr and Mrs Giuseppe Ciucci
Count and Countess Emilio Voli
The Rothschild Foundation

This exhibition has been made possible by the provision of insurance through
the Government Indemnity Scheme. The National Gallery would like to thank
HM Government for providing Government Indemnity and the Department for
Culture, Media and Sport and Arts Council England for arranging the indemnity.

First published in 2023 by
National Gallery Global Limited
Trafalgar Square
London WC2N 5DN
www.shop.nationalgallery.org.uk

ISBN: 9781857097108
1052658

British Library Cataloguing-in-Publication Data
A catalogue record is available from the British Library
Library of Congress Control Number: 2023940080

Publisher: Laura Lappin
Project Editor: Flora Allen
Copy-editor: Katharine Ridler
Picture Researcher: Suzanne Bosman
Production: Jane Hyne and Justine Montizon
Designed and typeset in Optima by Raymonde Watkins
Origination by DL Imaging, London
Printed in Belgium by Graphius

All works are by Francesco Pesellino unless otherwise stated.
All measurements give height before width.

Front cover: detail of cat. 8; back cover: detail of cat. 6; pp. 2–3: detail of cat. 6;
pp. 4–5: detail of cat. 8; p. 6: detail of cat. 6; pp. 46–7: detail of cat. 1;
p. 79: detail of cat. 6; p. 80: detail of cat. 2.